THE
UNSEEN
OLYMPIC

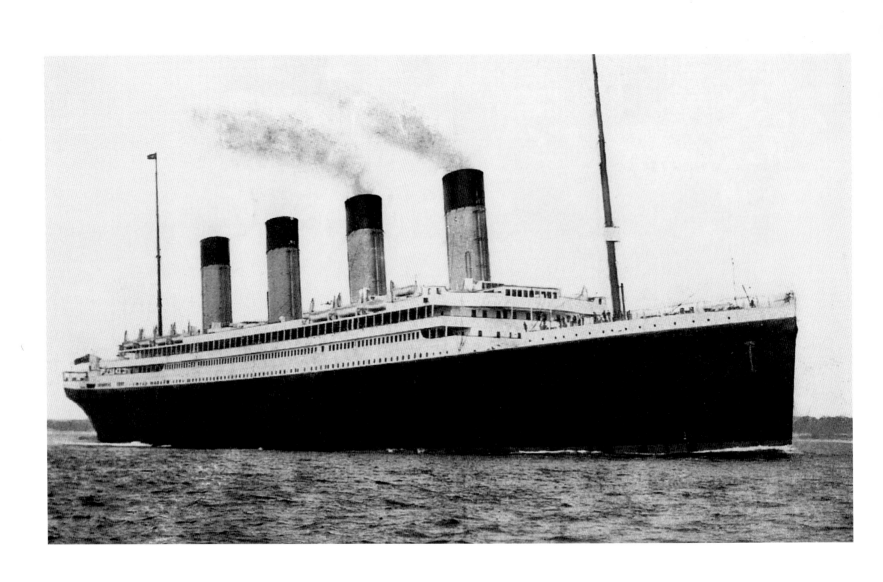

THE UNSEEN OLYMPIC

THE SHIP IN RARE ILLUSTRATIONS

PATRICK MYLON

The History Press

Dedicated to:

Joseph Bruce Ismay, Chairman of White Star Line (1899–1913), 1862–1937

Thomas Andrews Jr, Managing Director of Harland and Wolff (1907–12), 1873–1912

Every effort has been made by the author to seek out and acknowledge copyright ownership of all images.
If any omission has been made please contact the author via the publishers.

First published 2013
This paperback edition published 2017

The History Press
The Mill, Brimscombe Port
Stroud, Gloucestershire, GL5 2QG
www.thehistorypress.co.uk

British Library Cataloguing in Publication Data.
A catalogue record for this book is available from the British Library.

ISBN 978 0 7509 8267 2

Typesetting and origination by The History Press
Design by Katie Beard
Printed in India

CONTENTS

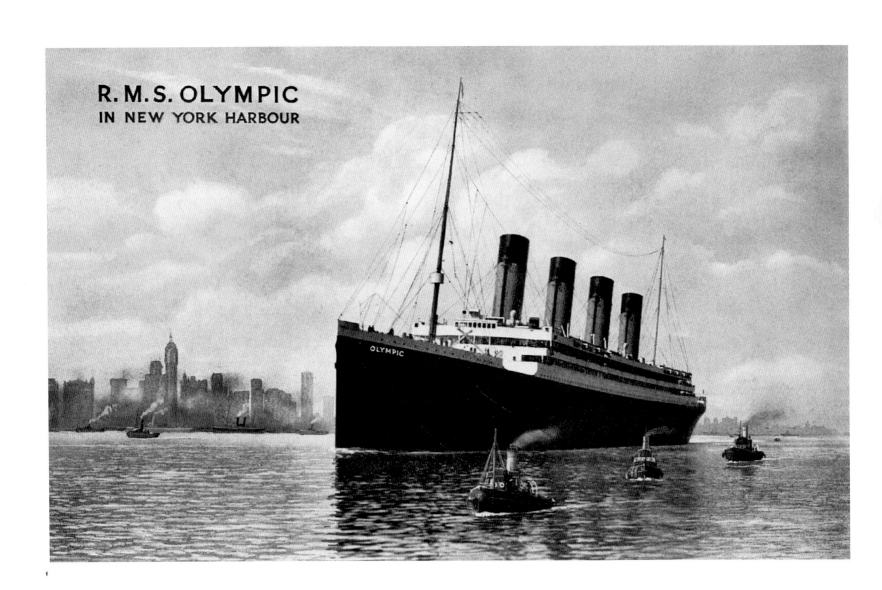

R. M. S. OLYMPIC
IN NEW YORK HARBOUR

ACKNOWLEDGEMENTS

Mr Emanuel Silberstein and Ms Patti Aronsson of Washington DC, for so many years of friendship and encouragement in all things White Star!

Mr Thomas and Mrs Suzanne Hegedus for many years of friendship and hospitality, but especially for allowing me to work on my two books whilst a guest at their beautiful home in France.

The Irish Titanic Historical Society's Ed Coghlan, for his research into the name 'Olympic'.

Ms Caroline Mylon, Mr Iain Yardley and Mrs Janina Stamps for, once more, all their technological assistance to an improving dinosaur!

Finally, those really nice people at The History Press, especially Ms Amy Rigg and Ms Christine McMorris, for having sufficient faith in me to ask for a second book and to all the departments at that company who do such a brilliant job in producing the excellent end product.

PREFACE

On telling friends and acquaintances that The History Press had asked me to write a book for their 'Unseen' series, and that the subject was to be the White Star liner *Olympic*, I discovered that many were unaware that the liner *Titanic* had one sister ship, let alone two!

My main objective in researching *Olympic* was to let people know just how much history was attached to this lesser-known vessel, and the contribution she made to sea travel for a major part of the first half of the twentieth century. Of course, there are many of you out there who are well aware of RMS *Olympic* and her story, but I hope that you also will find this book interesting, informative and, importantly, different.

My first challenge was the word 'unseen' until I realised that probably no one has seen all the images of a ship that was around for nearly a quarter of a century. I decided, therefore, to draw upon my extensive collection of *Olympic*-related postcards. Realising that very few would wish to see over 150 pictures of the same vessel, I chose also to include those cards featuring ships that were affected by and involved in the life of RMS *Olympic*.

All the illustrations are taken from my own collection of postcards and, wherever possible, I have endeavoured to acknowledge every publisher, photographer or artist to whom we owe an enormous debt of gratitude. Without the efforts of these people many of the images would never have survived the years. The tonnage of a particular vessel, if shown, is 'gross registered'. For those of you wishing to read more about this often overlooked vessel, I recommend the excellent publications featured in the bibliography section of this book.

Olympic was the first and by far the most successful of her class, but was overshadowed by the unfortunate fate of her two sister ships, *Titanic* and *Britannic*. I would like to take her out of those shadows and show you a beautiful ship that faithfully served her owners and country in times of peace and war.

Patrick Mylon

BEST LAID PLANS

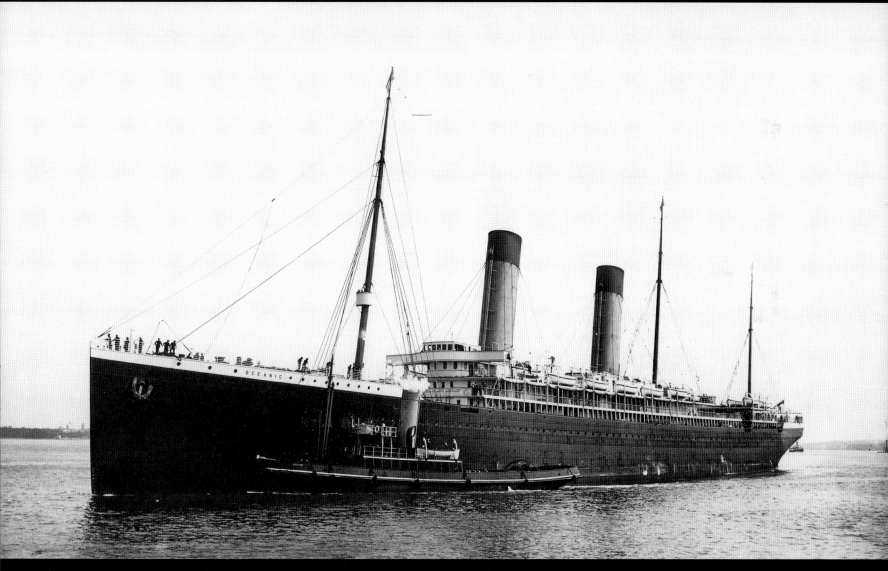

The second occasion upon which White Star Line considered the name 'Olympic' was for the proposed sister ship to their *Oceanic* of 1899. (Nautical Photo Agency)

The Oceanic Steam Navigation Company, better known as the White Star Line and founded by Thomas H. Ismay in 1869, had, in co-operation with Belfast shipbuilders Harland and Wolff, grown to become one of the most famous shipping companies in the first decade of the twentieth century.

White Star had contemplated using the name 'Olympic' as far back as 1888. In the margin of the Annual Report to 30 June of that year, in the archives of Harland and Wolff, there is a note that the names of White Star's new 9,710-ton vessels *Majestic* and *Olympic* were changed to *Teutonic* and *Majestic*. The second time that White Star had considered using the name was for the proposed sister ship to their ground-breaking new liner *Oceanic*.

White Star Line had, by the time of *Oceanic*'s construction in 1899, decided no longer to compete with the record-breaking speed of the opposition and concentrate primarily on comfort, reliability and punctuality

Celtic was the first of the 'Big Four' vessels and is believed to be an improved version of the proposed but cancelled *Olympic*. (B. Feilden)

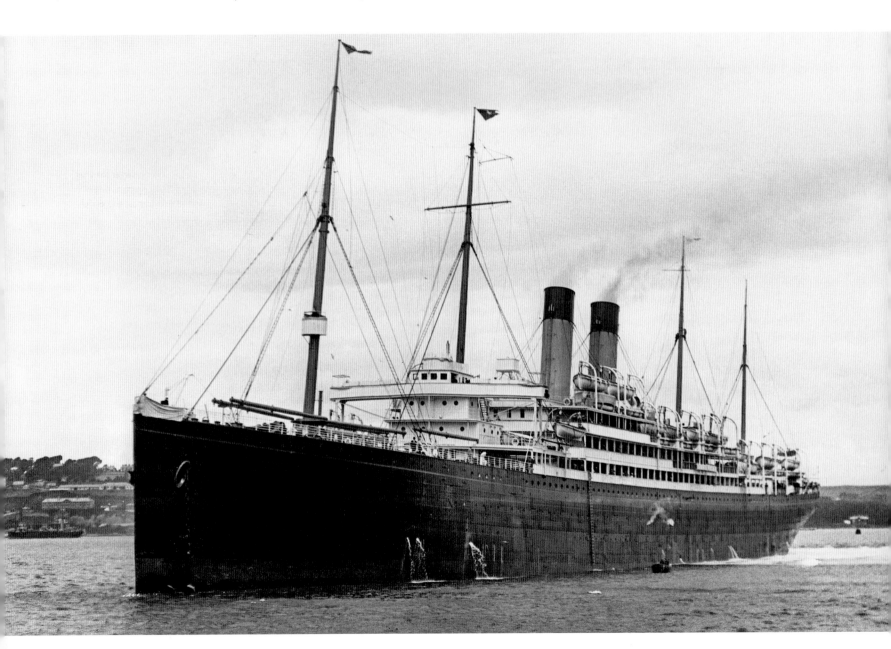

Cedric, slightly larger than her sister Celtic, became one of White Star's most successful vessels.

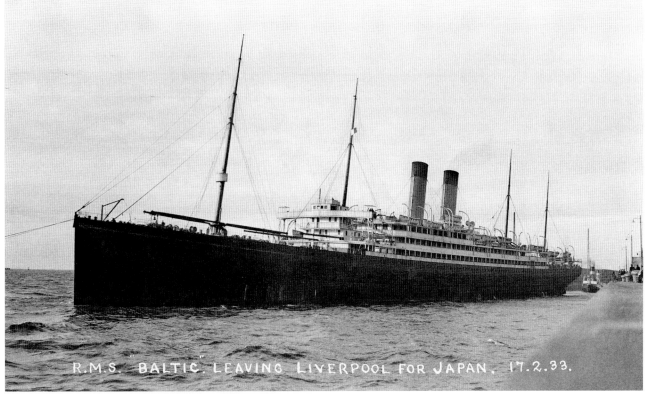

Baltic, the third vessel of the 'Big Four', was somewhat underpowered owing to White Star's decision to increase her size but not reflect that increase in her engine design. She is seen here leaving for demolition in Japan. (B. & A. Feilden)

while still maintaining a moderate speed. Considerable savings were thus made in fuel consumption and their vessels, without the size restrictions of the Atlantic greyhounds, also benefited from a greater passenger and freight capacity.

Thomas Ismay died, aged 72, on 23 November 1899, and the running of the business was taken over by, amongst others, his son J. Bruce Ismay. It was at this time that the decision was made to cancel the proposed *Olympic*. In fact, plans had already been made for an even larger vessel, *Celtic* (1901–28), which was to become the first of White Star's famous 'Big Four'. She would be followed

by *Cedric* (1903–32), *Baltic* (1904–33) and finally *Adriatic* (1907–35). Each vessel, when launched, was slightly larger than her predecessor and the largest in the world.

Meanwhile, across the Atlantic, the American financier J. Pierpont Morgan, who had in 1901 created his International Mercantile Marine Company, began purchasing several established shipping companies, including some British ones. White Star Line was acquired for this giant combine in December 1902 and J. Bruce Ismay, who since the death of his father had been Chairman of White Star Line, was appointed President of the International Mercantile Marine Co. (IMM) in 1904.

Adriatic, the fourth and last of the quartet, survived into Cunard-White Star ownership.

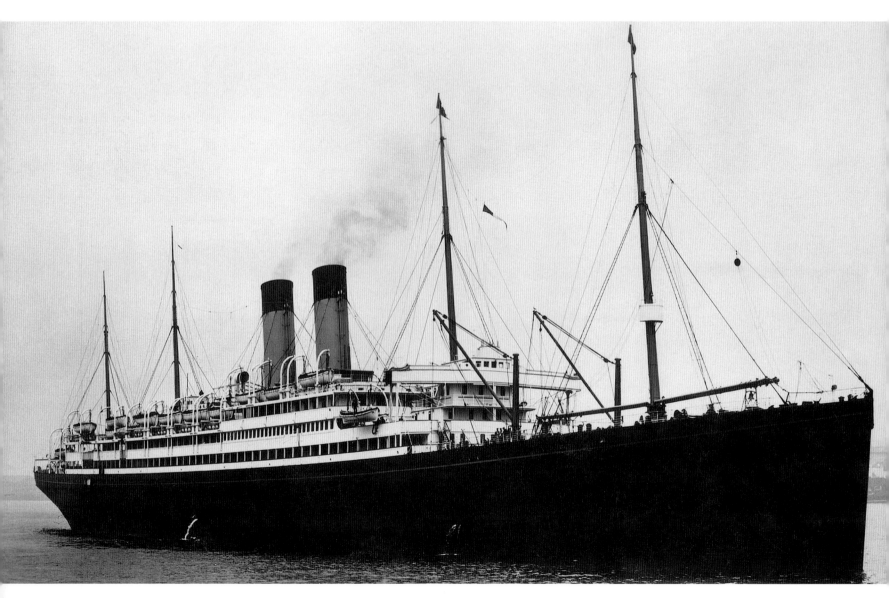

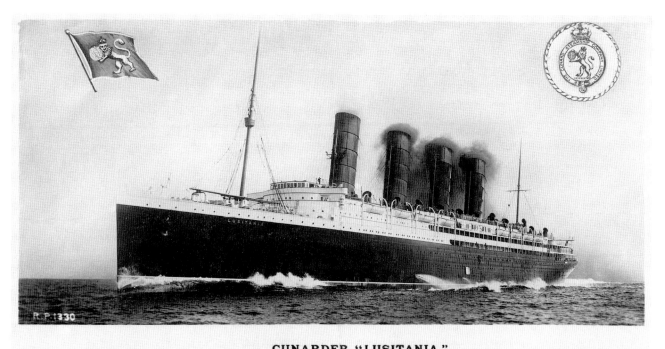

CUNARDER "LUSITANIA."

Length	790 feet.	Height to top of Funnels	155 feet.
Breadth	88 ,,	Height to Mastheads	216 ,,
Depth to Boat Deck	...	80 ,,	Passenger Accommodation, 1st class	550		
Draught (fully loaded)	...	37 ,, 6 inches	,, ,, 2nd class	500		
Displacement on load draught	45,000 Tons.	,, ,, 3rd class	1,300			
Horse-Power of Turbine Engines, 68,000 ,,	Crew	800 to 900				

Cunard's *Lusitania* represented the beginning of the threat to White Star's 'Big Four' vessels. (Rival Photographic)

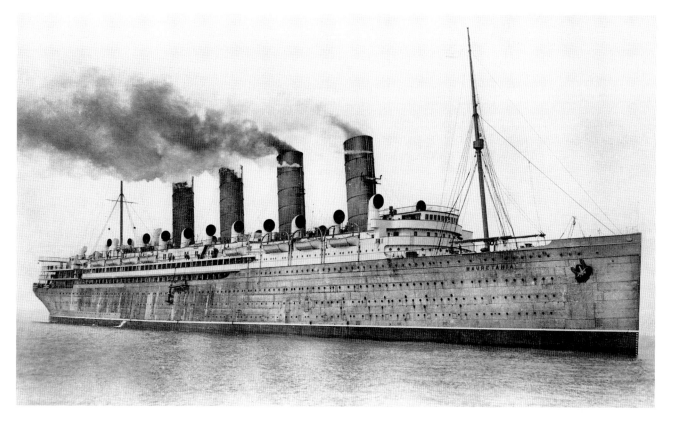

Mauretania, identified by her greater number of ventilator cowls, followed her sister ship *Lusitania* within three months. The message on the reverse of this card, posted at Queenstown, Ireland, on 12 July 1908, refers to the excessive vibration of the vessel.

Britain's Cunard Line, concerned at the rapid expansion of Pierpont's empire, approached the government for protection. Parliament approved a loan of £2.6 million to Cunard for the construction of two super liners with the proviso that the company would remain in British control for the next twenty-five years. These two vessels, *Lusitania* and *Mauretania*, each captured the transatlantic speed record and became the largest vessels in the world at the time of their completion. *Lusitania* made her maiden voyage in June 1907, followed three months later by *Mauretania*.

On the day of *Mauretania*'s launch on the Tyne, 20 October 1906, the last of White Star Line's 'Big Four', *Adriatic*, took to the water at Belfast. She would be the first vessel to feature a swimming pool and Turkish bath for her first-class passengers. However, it had become clear to White Star that they were up against serious competition from the two new Cunard liners, not to mention the ever-increasing threat from the German mercantile marine.

Lord Pirrie, Chairman of Harland and Wolff since 1906, invited J. Bruce Ismay and his wife to dinner at his London

Harland and Wolff's new Arrol gantry was built specifically for the construction of the new Olympic-class vessels.

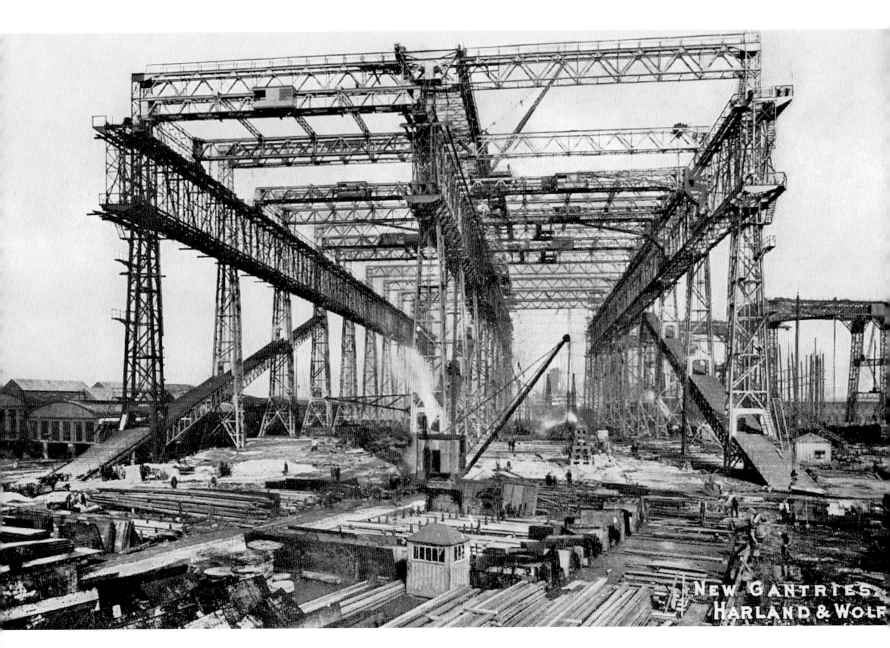

NEW GANTRIES
HARLAND & WOLFF

home in Belgravia one summer evening in 1907. It was at this meeting that the initial plans were discussed to construct two large vessels to compete with Cunard, to be followed later by a third. These vessels, to become known as the Olympic class, were to be the largest ever built and, at 5 knots faster than the 16 knots of the 'Big Four', the fastest in the White Star fleet. In addition, it was decided that they were to be the most luxurious vessels afloat.

To cover the estimated £3 million cost of the first two vessels, Ocean Steam Navigation Co. increased their share capital by £2.5 million and a letter of agreement was signed by White Star and Harland and Wolff on 31 July 1908. As per the agreement between the two companies, the construction would be on a 'cost plus' basis whereby Harland and Wolff would charge White Star with the cost of the building, using the best materials available at the time, then add their 4 per cent commission.

Lord Pirrie would remain in overall control at Harland and Wolff, but directly beneath him would be General Manager Alexander Carlisle (ret. 30 June 1910) and Chief

The Benrather floating crane, purchased from Germany for the post-launch fitting-out work on *Olympic* and *Titanic*. The message on this card, posted from Belfast in August 1915, reads: 'when wanting a messenger you can never get one'.

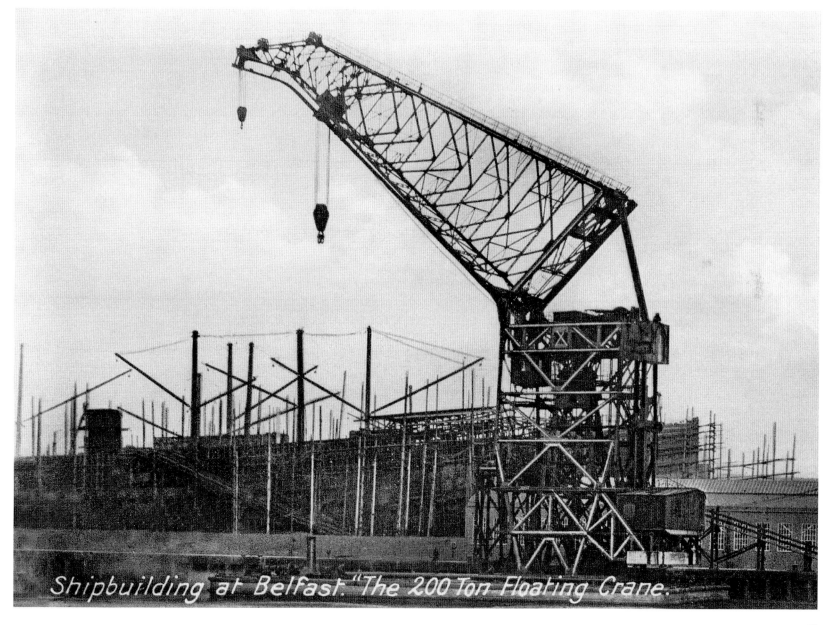

Shipbuilding at Belfast. "The 200 Ton Floating Crane.

WHITE STAR LINE

THE LARGEST STEAMERS IN THE WORLD.

THE LARGEST STEAMERS IN THE WORLD.

"OLYMPIC" (TRIPLE-SCREW), 45,000 TONS,
AND
"TITANIC" (TRIPLE-SCREW), 45,000 TONS.

One of the first artist's impressions of the proposed new liners. The artist, Montague Black, became a favourite with the White Star Line.

Designer Thomas Andrews MD. Pirrie and Ismay together had conceived the vessels, but the responsibility for their design and construction would lie initially with Carlisle.

Funded by a loan from IMM, the North Yard at Belfast was reconstructed to handle the building of the two super liners. The original site accommodated four slipways covered by three gantries. One slip remained as it was and the gantries were moved above. Two new slips were created on the site of the remaining three and a new gantry, designed by Sir William Atholl & Co. of Glasgow, was built

above at a cost of £100,000. This giant gantry (840ft x 270ft x 228ft) would dominate the Belfast skyline for decades.

Delivered in October 1908, an enormous floating crane was purchased from the German Benrather Company for the fitting out of the vessels after launch.

White Star Line announced, on 16 April 1908, that the first vessel would be named *Olympic* and, six days later, it was revealed that the second would be named *Titanic*.

The keel was laid on slip number two for the first vessel, *Olympic*, on 16 December 1908, followed by

Olympic, the centre vessel, in a more advanced state of completion than her sister, *Titanic*, to the right. (Doherty of Belfast)

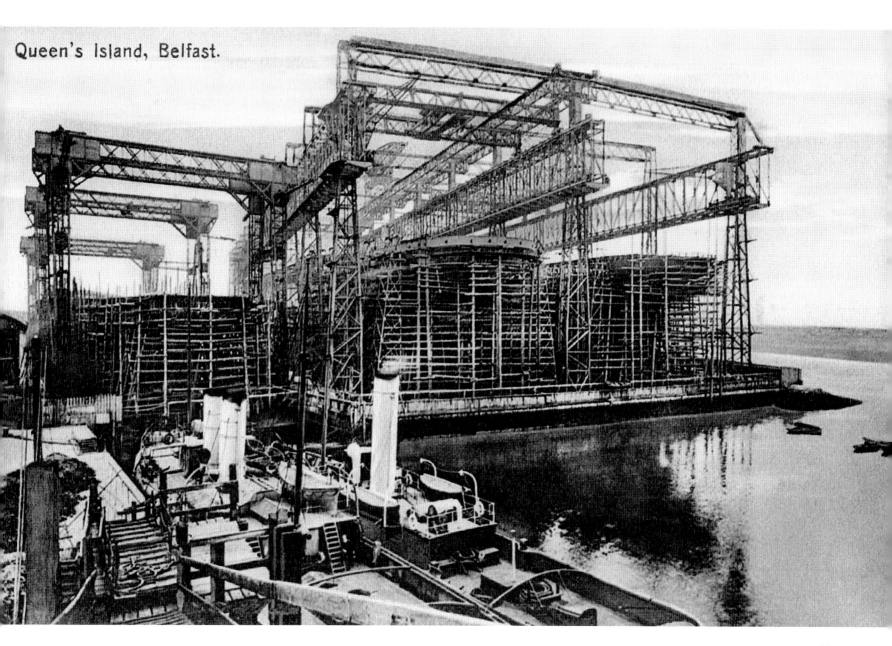

Queen's Island, Belfast.

that of *Titanic* on slip number three on 31 March 1909. Construction of *Olympic* began before slip number three was completed. *Olympic* would be finished within twenty-two months and *Titanic* within twenty-six.

Of the 14,000 men at Harland and Wolff, between 3,000 and 4,000 were employed on the construction of *Olympic*. Initially there was to be a three-month gap between the completion of the two liners but this widened as more men were switched to *Olympic*'s construction to ensure a confirmed launch date.

Despite a size differential of over 10,000 tons, the Olympic-class liners, at 45,324grt, would only be approxi-

mately 3 knots slower than *Mauretania* and *Lusitania* and would use far less fuel. *Olympic* would average a daily coal consumption of 674 tons compared to the 1,050 tons of the Cunard ships. The overall length of each of the vessels would be 882ft, with a breadth of 92ft, and the design of the watertight compartments would ensure that the vessel could float with any two open to the sea or any four forward or aft.

Two liners, *Laurentic* (April) and *Megantic* (June), had been built in 1909 for White Star's joint Canadian service with the Dominion Line, and each was propelled by a different system. *Laurentic* was supplied with three screws

Without a real vessel to work on, this photographer has doctored Cunard's *Mauretania*. The message on the card, posted at Southampton in June 1911, reads: 'Viewed boat yesterday'.

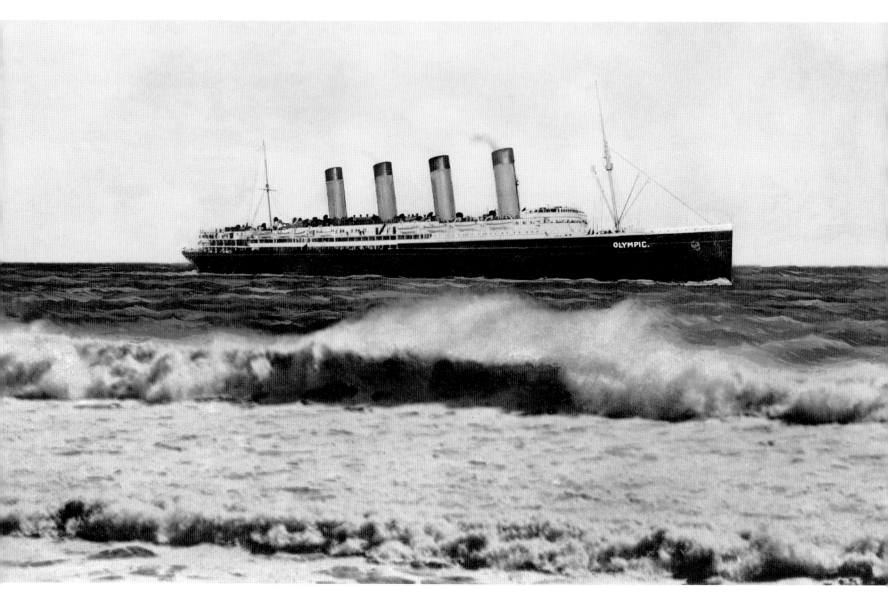

Built for the Canadian service, *Laurentic*'s triple-screw propulsion system was adopted for the Olympic-class liners. (C.W. Hunt & Co.)

White Star's *Megantic*. Her twin screws provided 15 per cent less power than the triple screws of her sister *Laurentic*.

featuring a combination of two outer powered by triple-expansion engines and a central screw driven by a turbine powered by low-pressure excess steam. *Megantic* was fitted with only two propellers powered by standard reciprocating engines. At an average speed of 16.5 knots, it was found that *Laurentic*'s system consumed 15 per cent less coal and it was this triple-screw arrangement that was chosen for the new Olympic-class liners.

On *Olympic* and *Titanic* the two outer propellers, at 38 tons with three bronze blades, and the central, 22-ton, four-bladed, moulded propeller were powered by two engines (four decks high and the largest ever yet built) supplied with steam from twenty-four double-ended boilers and five single-ended auxiliary boilers. This arrangement was designed to produce a service speed of approximately 21 knots. Ship's dynamos would supply the 10,000 lights or more, with emergency dynamos for 500 lights and the wireless apparatus.

The sixteen lifeboats, required by the British Board of Trade, would be grouped in four individual four-boat sets of davits fore and aft on each side, with four additional collapsible boats located forward. Despite each set of Welin Quadrant davits being capable of handling four lifeboats, White Star Line considered that such an arrangement occupied valuable deck space and thus one boat only was allocated. Neither vessel featured any form

Ready for launch, *Olympic*'s hull was painted light grey to aid photography. The message on this card, posted in Brighton on 2 November 1910, reads: 'another view of the Olympic'.

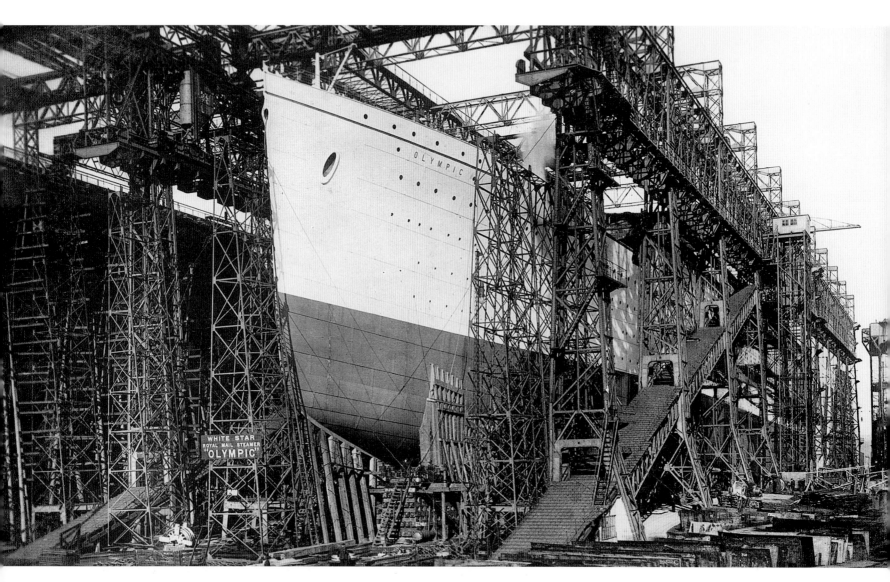

of public-address system. These omissions were to have fatal consequences in 1912.

The magazine *The Shipbuilder*, in their June 1911 edition which was dedicated to the new super liners, stated: 'The captain may, by simply moving an electric switch, instantly close the watertight doors throughout, making the vessel virtually unsinkable.'

Meanwhile, on each side of the Atlantic, plans were afoot to accommodate these giant liners. The London and South Western Railway, at Southampton, extended and dredged the Trafalgar dock built in 1905. This work was completed in 1913 and berths 43, 44, 46 and 47 became known as 'The White Star Dock', encompassing over 16 acres and with a depth of nearly 40ft. In 1922 the name was again changed, this time to 'Ocean Dock'. White Star Line had transferred their express New York service from Liverpool to Southampton in 1907 to capture a share of the lucrative European market at Cherbourg in France. Cunard Line was not to move until after the First World War. New York proved to be a harder nut to crack but, after initial opposition and an IMM appeal to Washington, it was agreed that the Hudson piers would be lengthened and the river deepened.

The hull of *Olympic*, painted grey for publicity purposes, was launched on Thursday 20 October 1910. British and American flags flew from the Arrol gantry and, on that

The newly launched hull of *Olympic* being manoeuvred into position alongside Alexandria Wharf, with the 200-ton floating crane clearly visible behind. (W.E. Walton)

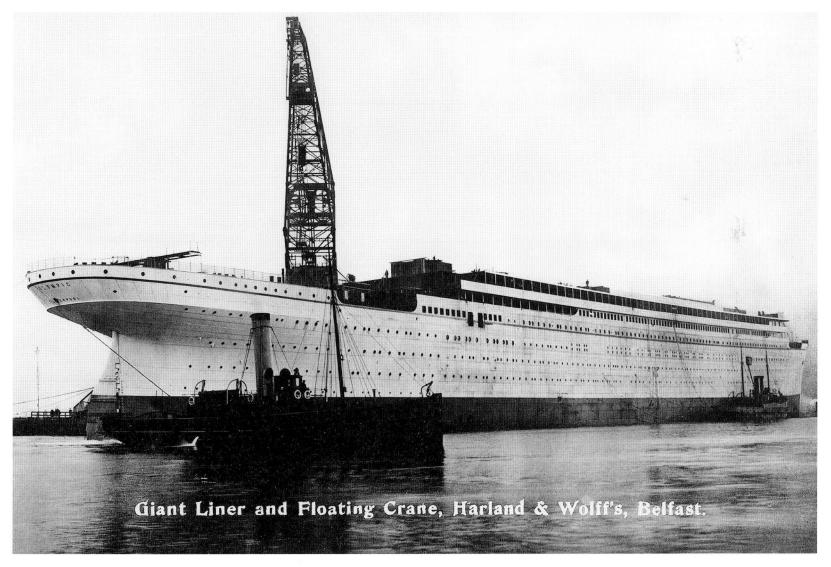

Giant Liner and Floating Crane, Harland & Wolff's, Belfast.

Olympic's fourth and last funnel being lowered into position. This funnel was a dummy, being for ventilation purposes and kitchen exhaust only. Inland postage is shown as a 'halfpenny' with foreign at one 'penny'.

sunny and windy day, two rockets were fired at 10.50 a.m. with another at 11 a.m. Hydraulic rams and triggers were released and *Olympic* reached the water sixty-two seconds later, having achieved a speed of 12½ knots. Within forty-five seconds the hull was stopped. Over 20 tons of soft soap and tallow on the slip had helped her on her way. Hundreds of dignitaries and members of the press had witnessed the event, having been brought over from Liverpool on the chartered steamer *Duke of Cumberland*.

After her launch, *Olympic*'s 20,600-ton hull was moored alongside Alexandria Wharf where fitting out would take place. In addition to engines and boilers, miles of wiring and piping, and all that was required to convert her empty steel hull into a passenger liner was now installed.

With her four funnels now in place, the fourth being a dummy catering for the exhaust from the first- and second-class galley on 'D' deck as well as for engine room ventilation, *Olympic* finally entered the new Thompson dry dock on 1 April 1911. Here in this dock, which had taken seven years to build at a cost of £350,000, her propellers were fitted, the hull painted in White Star Line colours and she was registered at Liverpool on 25 May 1911. During this period *Olympic* was opened to the public on 27 May 1911 at a cost of 5s per person in aid of local Belfast hospitals.

Two days of sea trials commenced on 29 May 1911 with the two new tenders *Nomadic* and *Traffic*. These two vessels had been built at Harland and Wolff for tendering services at Cherbourg, as the facilities there would not enable the new liners to berth alongside and the

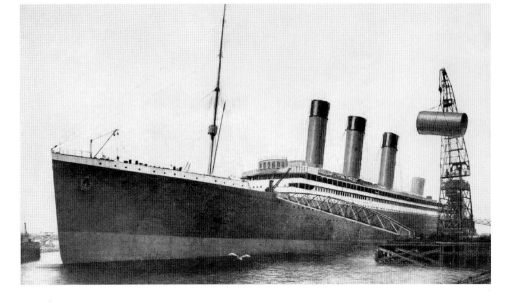

With scaffolding still evident on her rear two funnels, *Olympic* is fast nearing completion. The message on the reverse shows that this card was 'bought on board 16th June 1911'.

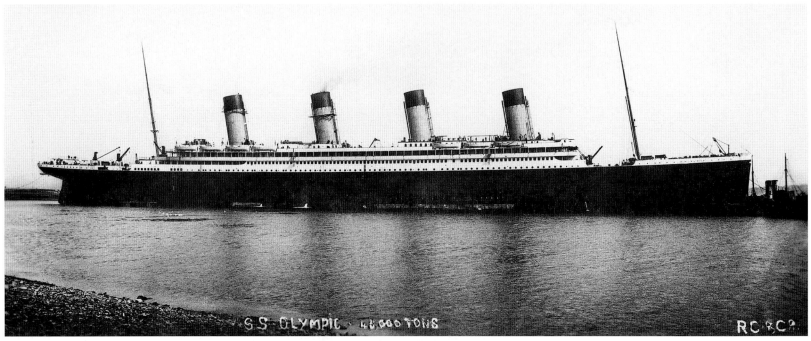

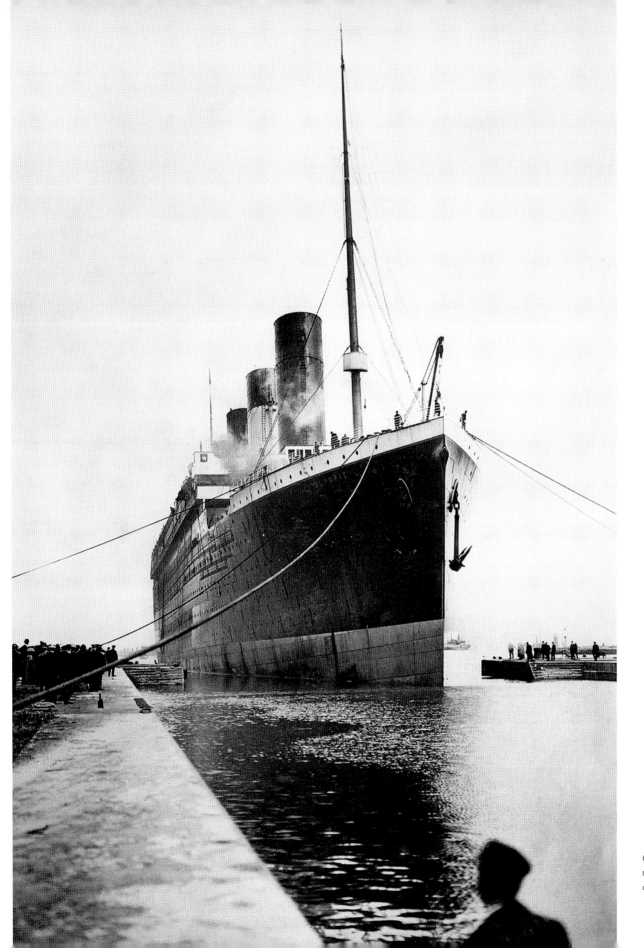

Olympic shown entering the
new Thompson dry dock for final
completion. (Real Photo Series)

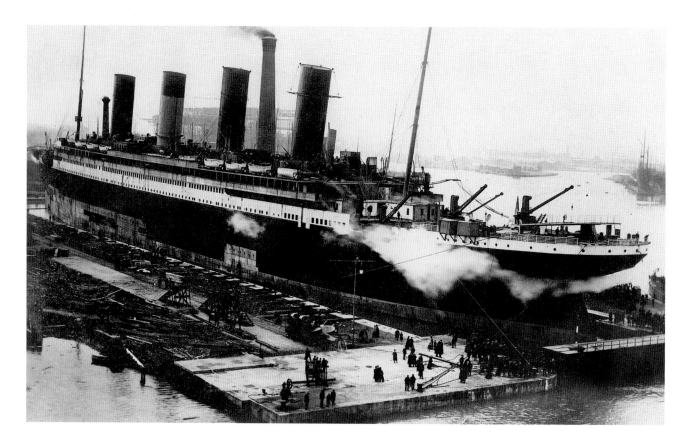

With most of her lifeboats now in place, *Olympic* is about ready for her trials whilst, in the distance, work continues on *Titanic*. Often, in many photographs of this scene, the large chimney behind is removed from the picture.

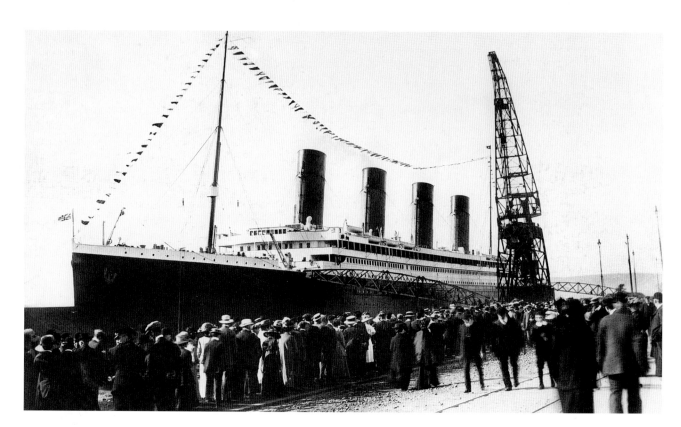

The public queuing to view the magnificent new *Olympic* before her trials. They had each paid 5s which was donated to charity. (Real Photo Series)

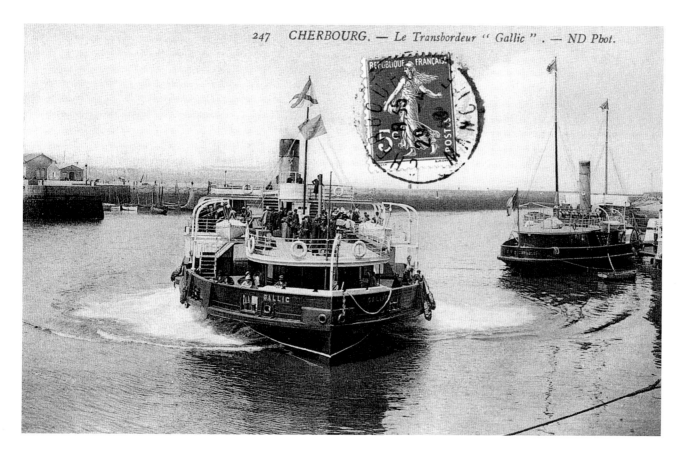

247 CHERBOURG. — Le Transbordeur " Gallic ". — ND Phot.

A stern view of the ageing paddle tender *Gallic* at Cherbourg. She would have been inadequate for the new Olympic-class vessels. Note the French practice, at the time, of placing the postage stamp on the front of the postcard.

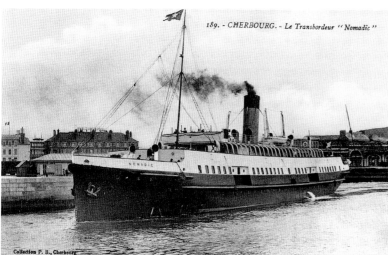

189. - CHERBOURG. - Le Transbordeur " Nomadic "

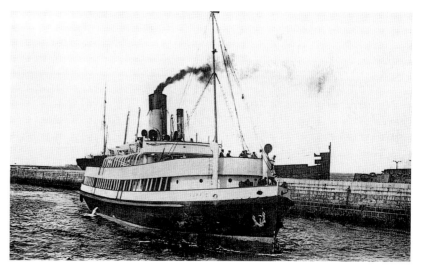

Nomadic, the larger of the two tenders built for the port of Cherbourg, primarily accommodated first- and second-class passengers. The note on the reverse reminds us that 'No foreign countries accept correspondence on the reverse – ask at Post Office'.

The smaller Cherbourg tender, *Traffic*, was mainly used for third-class passengers and baggage. This card was posted from Le Havre in 1929, by which time postage stamps were affixed to the correspondence side.

elderly existing tender *Gallic* was unsuitable for the new Olympic-class vessels. *Nomadic* (1,273grt) and *Traffic* (675grt) were twin-screw propelled and each could accommodate 1,200 passengers with their baggage.

Olympic was handed over, after successful trials, to White Star Line on 31 May 1911. That same day, in front of a crowd of over 100,000 people, *Olympic*'s sister ship *Titanic* was launched at 11 a.m. As per Harland and Wolff and White Star Line's usual practice, neither vessel was launched with the traditional 'naming with champagne' ceremony. White Star Line hosted a lunch for the visiting dignitaries at the Grand Central Hotel in Belfast. Commanded by Captain E.J. Smith, senior captain and commodore of White Star Line, *Olympic* departed

Belfast at 4.30 p.m. for a courtesy call at Liverpool, to arrive on 1 June 1911. There she would be open to the press and public for a fee of half a crown to go to local charities. The number of visitors increased later in the day after the fee was reduced. Meanwhile, the little *Nomadic* and *Traffic* headed for the port of Cherbourg to await *Olympic*'s maiden voyage arrival.

Shortly after midnight on 2 June 1911, Olympic departed Liverpool for Southampton, where she arrived early in the morning of 3 June. Work was still on going at the White Star dock and she berthed bow-first. Until her departure she would become a hive of activity as food and provisions, cutlery and crockery, linen and towels were embarked. In addition was the dirty task of coaling the bunkers.

This card, posted from Belfast in 1911, shows *Olympic* departing from Belfast after the successful launch of her sister ship *Titanic*. (Real Photo Series)

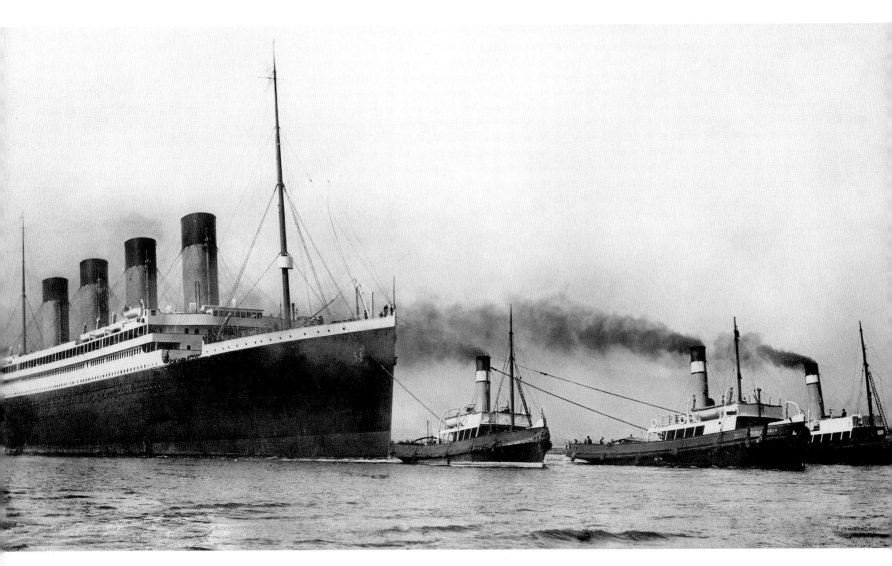

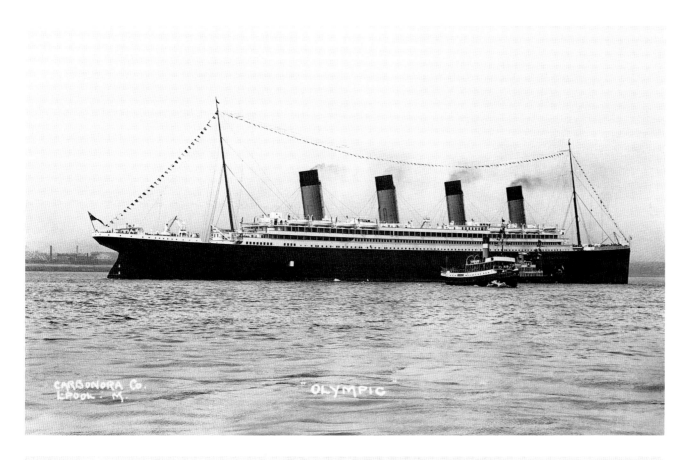

Olympic in the River Mersey, making her courtesy call to Liverpool on 1 June 1911. (Carbonara Co.)

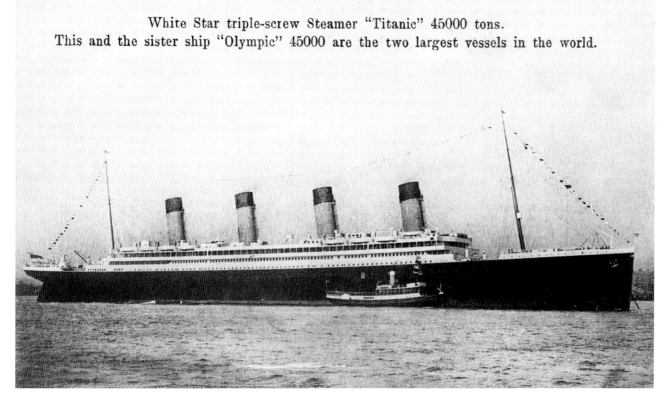

White Star triple-screw Steamer "Titanic" 45000 tons.
This and the sister ship "Olympic" 45000 are the two largest vessels in the world.

Another photograph of Olympic taken during her visit to Liverpool. She is incorrectly identified here as her sister Titanic.

Olympic, dressed overall, is berthed at Southampton as preparations are made for her maiden voyage. (Rotary)

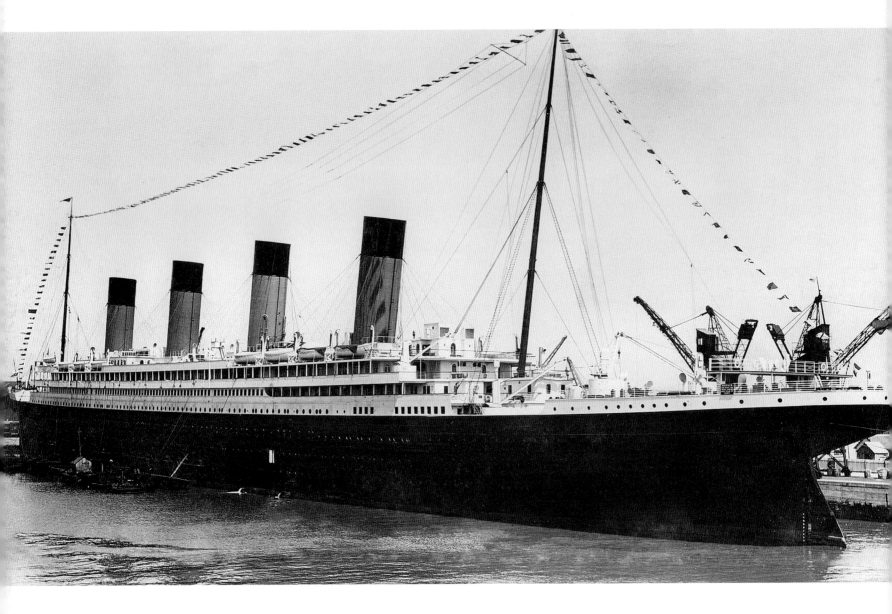

WORLD'S LARGEST

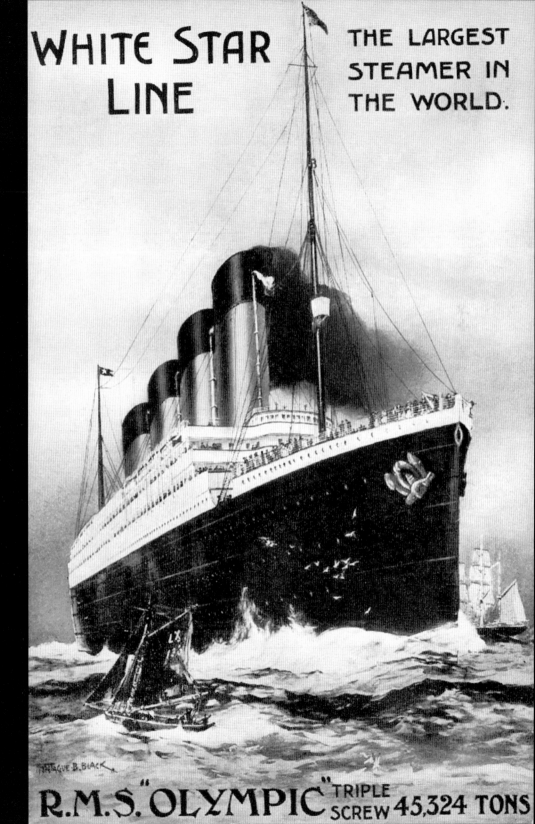

WHITE STAR LINE

THE LARGEST STEAMER IN THE WORLD.

MONTAGUE B. BLACK

R.M.S. "OLYMPIC" TRIPLE SCREW 45,324 TONS

Montague Black's illustration
used again to promote *Olympic*
as the 'World's Largest Steamer'.

White Star Line's express New York service from Southampton had been operated with *Adriatic*, *Oceanic*, *Majestic* and her sister ship *Teutonic*. *Olympic* had been built solely for this route and, with her arrival at Southampton, *Adriatic* rejoined her sisters on the Liverpool to New York schedule whilst *Teutonic* was switched to the Canadian operation.

The scheduled weekly sailing from Southampton departed Wednesday noon for a call at Cherbourg, continuing overnight to Queenstown (now Cobh), Ireland, to arrive at noon on Thursday. From Queenstown it crossed the Atlantic to arrive in New York on the morning of the following Wednesday. Occasionally, if routed via the northern track, the arrival could be on the Tuesday evening. The schedule called for a departure from New York four days later, at noon on Saturday, for a first stop-over at Plymouth, as passengers saved a day by taking the direct train to London, then continuing on to Cherbourg to arrive in Southampton on Friday evening.

Until the maiden voyage departure on 14 June, *Olympic* dominated Southampton, resplendent in her gleaming new paint with the black hull separated from the white

One of the first gymnasiums afloat, illustrated here on a card mailed on 28 January 1926. The name 'RMS Olympic' is clearly visible under the image on the right of the photograph.

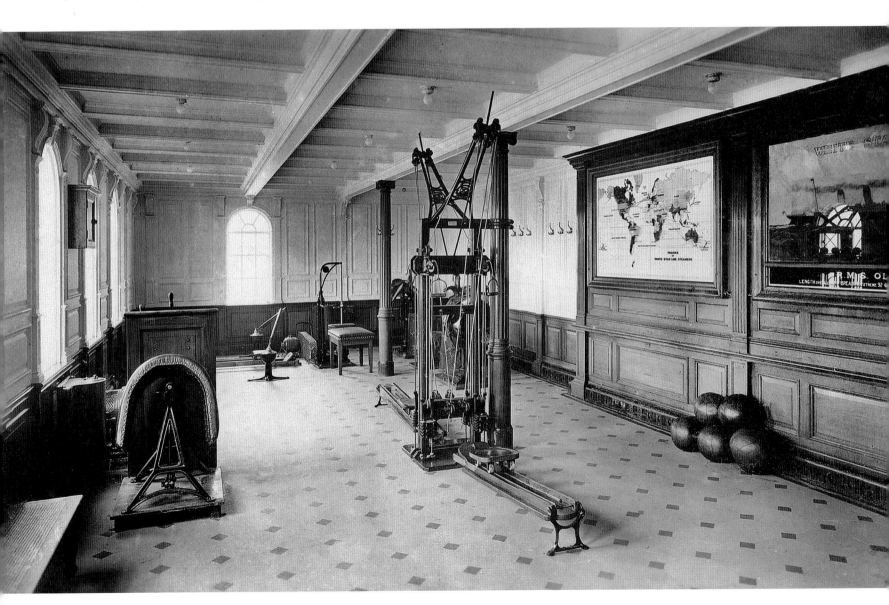

superstructure by a 10in yellow band and her tower-ing buff funnels with black tops. She would be opened to the public on 10 June, with monies being donated to local charities. For the remainder of the time provi-sions were loaded, coal was supplied and crew joined the vessel. During this period the coaling workforce at Southampton went on strike and White Star was obliged to bring in their own men recruited mainly from the miners of Yorkshire.

Olympic was registered to carry up to 2,590 passengers: 1,054 in first class, 510 in second and 1,026 in third (steer-age). It was possible, if necessary, to interchange some cabins between the first and second classes. The minimum one-way fares would, if using today's currency, be approxi-mately £1,600 first class, £800 second and £450 third.

Four Waygood lifts, three in first class and one in second, each with a capacity of twelve persons, were car-ried. The second-class lift, serving six decks, would prove to be a very popular innovation.

In first class the gymnasium, located on the boat deck and measuring 44ft x 18ft, was available to men between 2 p.m. and 7 p.m., to ladies between 10 a.m. and 1 p.m., and to children between 1 p.m. and 3 p.m. On the lower 'F' deck were *Olympic*'s swimming pool, Turkish bath and squash racket court. The swimming pool, at approximately 30ft x 14ft, the largest afloat at the time, had a depth of about 5ft. In addition, there were thirteen changing cubicles and two showers. Similar time conditions to the gymna-sium also applied to the pool. The Turkish bath, tiled in blue and green and lit by bronze hanging Arabic lamps, included a cooling room, low couches and canvas chairs. It could be used for 4s or $1 per visit. The popular squash court, two decks high and the first ever at sea, was avail-able at a charge of 2s or 50¢ for half an hour.

Two grand staircases provided access to the first-class passenger decks. The more impressive of the two was located forward, served six decks, and was lit by a glass and iron dome above. At the top of this main grand stair-case was to be found a large clock with two female fig-ures either side representing 'Honour & Glory crowning Time'. On 'C' deck, by this staircase, were the first-class purser's and enquiry offices where, amongst the many services provided, passengers could arrange for radio messages to be sent (12s 6d for ten words) and deposit

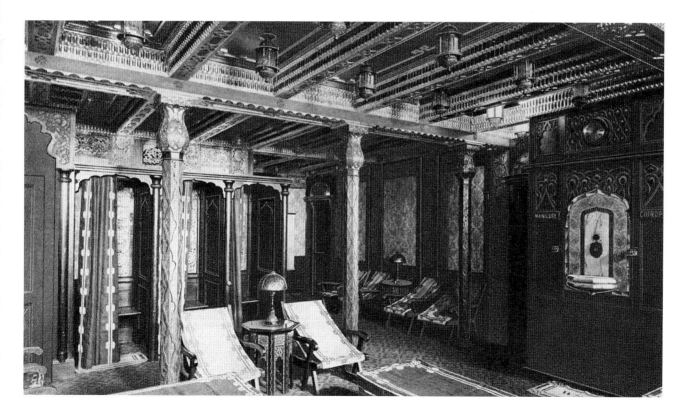

Initially 4s or $1 permitted one visit to the Turkish bath for *Olympic*'s first-class passengers. The cost had almost certainly increased by the time this card was published in the 1920s.

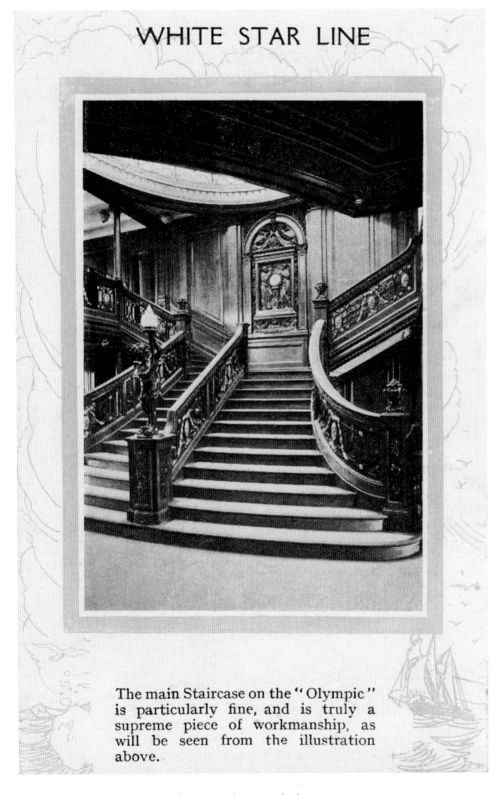

WHITE STAR LINE

The main Staircase on the "Olympic" is particularly fine, and is truly a supreme piece of workmanship, as will be seen from the illustration above.

This company-issued card promotes *Olympic*'s grand staircase, clearly illustrating the ornate clock. The glass and iron dome, providing daylight at the top, is just visible.

their valuables. Also on 'C' deck could be found the 'Maids and Valets Saloon', as well as the first-class barber and souvenir shop, and doctor's surgery.

The oak-panelled Louis Quinze-style main lounge, on 'A' deck, measured 59ft x 63ft and offered afternoon tea and after-dinner coffee. Additionally on 'A' deck, the Georgian 'Reading and Writing Room' was located. This carpeted room, with a bow window and a fire in the grate, was primarily aimed at female passengers, whereas on the same deck, the men were catered to by the smoking room aft of the lounge. The mahogany-panelled smoking room, measuring 61ft x 65ft, featured over the fireplace a painting by the well-known artist Norman Wilkinson entitled 'Approach to the New World'. Similarly, *Titanic*'s painting was entitled 'Plymouth Harbour'. Behind the smoking room on 'A' deck, the Verandah Café and Palm Court, decorated with green trellises and climbing plants, served light snacks between 8 a.m. and 11 p.m.

The main first-class restaurant, the largest afloat and located on 'D' deck, stretched across the ship 92ft and was 114ft long. Decorated in white early Jacobean style and carpeted throughout, the dining room only occupied one deck level. Meals were served here in two sittings, as the seating capacity at any given time was only 532. The 54ft-long reception room linked the restaurant to the grand staircase and it was here, also, that afternoon tea and after-dinner coffee were served.

Beneath the smoking room, on 'B' deck, the à la carte restaurant offered the 1912 equivalent of 'alternative dining' so popular on today's cruise ships. First-class passengers were required to pay extra to use this facility. Walnut panelled, in Louis XVI style with silk curtains over bay windows and an Axminster carpet, this restaurant was open from 8 a.m. until 11 p.m. and offered seating at twenty-five small tables for two to eight persons each. Advance booking was required as this dining room became very popular. So much so that, after two return crossings, the capacity was increased to forty-one tables. Should passengers decide at the time of booking to take all their meals in this restaurant they would be granted a discount on their passage rate.

First-class passenger accommodation lived up to White Star's promise to introduce the most luxurious vessels in the world, which they made when they announced the

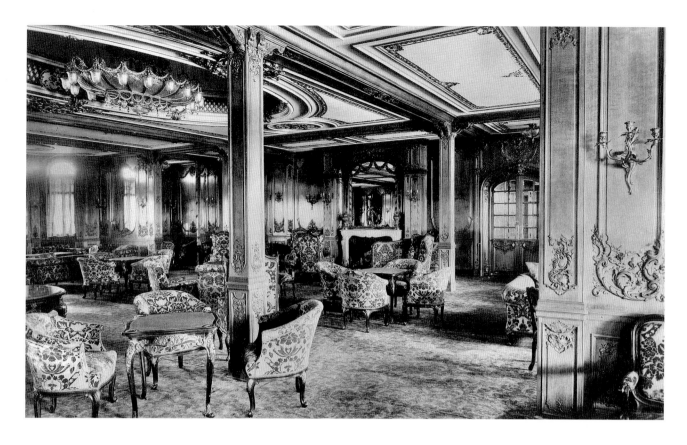

Olympic's oak-panelled first-class lounge, where afternoon tea and after-dinner coffee were served. (C.R. Hoffmann)

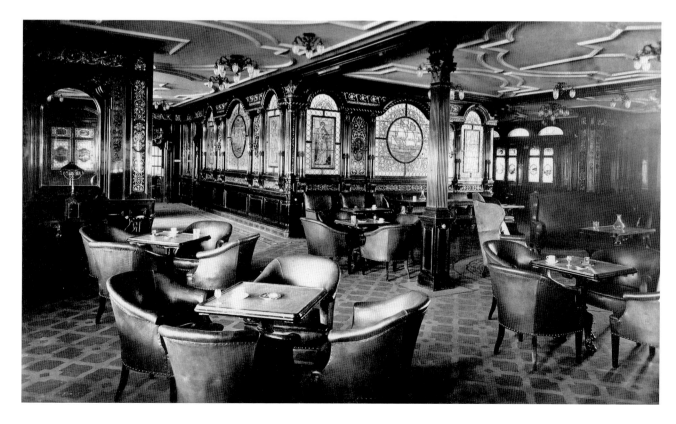

The ornate mahogany-panelled first-class smoking room catered, primarily, to *Olympic*'s male passengers.

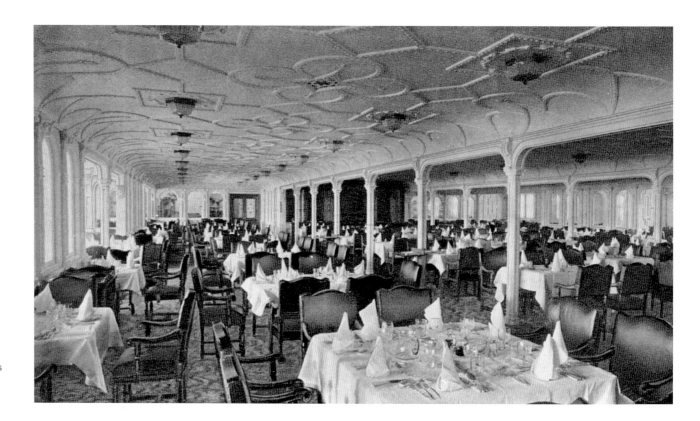

Carpeted throughout, *Olympic*'s first-class restaurant was the largest afloat in 1911.

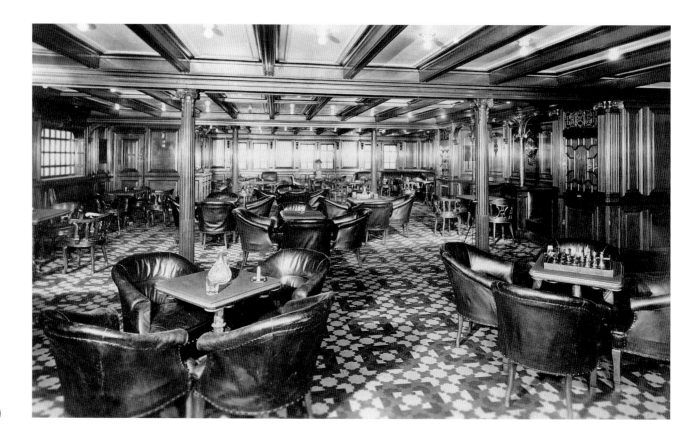

The second-class smoking room featured linoleum floor tiles and dark-green upholstery. Note the chess set on the right. (Kingsway)

plans for *Olympic* and *Titanic*. It included four parlour suites each comprising sitting room, two bedrooms, walk-in dressing room, private bath and toilet. There were, in addition, twelve further suites with bed and sitting rooms. These cabins had inter-connecting doors, enabling them to be sold separately if necessary. Many of the first-class cabins featured private baths and toilets, and there were approximately 100 cabins offering single accommodation.

Promenade space in first class was located on the forward part of the boat deck, as well as the entire 'A' deck below.

Second class, located aft on *Olympic*, was often superior to first class on other vessels. The dining room stretched the full width of the ship with linoleum-tiled flooring, mahogany furniture and crimson leather upholstery. Linoleum tiles were also to be found in the smoking room. This male-dominated room featured dark-green leather upholstery. The second-class lounge, lit by large windows, was softened by silk curtains and Wilton carpet.

All the second-class cabins featured wash basins and most extended to the side of the vessel. An oak-panelled staircase joined all seven decks, whereas the one lift served the first six. The second-class barber and souvenir shop, and purser's office were located on 'E' deck.

A second-class open promenade deck was located at the aft end of the boat deck, of approximately 145ft with a similar open space on 'B' deck. There was also a glass-enclosed 84ft of 'C' deck aft offering protected promenade space.

As with aircraft today, it is the economy section where the company makes money and this was much the same in 1911. The Olympic-class liners were designed to cater for the enormous number of steerage-class emigrants making their way to the New World. By 1907 the annual westbound numbers of emigrants from Europe had risen to over 1 million. Third (steerage) class on *Olympic* was, in many ways, far superior to the accommodation to which the bulk of the passengers were accustomed. Situated on the lower decks, cabins for married couples and single women featured wash basins, but those for single men, situated forward, offered none. As with Cunard, mattresses and blankets were supplied but not sheets.

A rare second-class dinner menu for *Olympic* during her sixth week in service. Postcard menus provided inexpensive advertising for White Star Line. The advertisement on the reverse reads: 'The Largest and Finest Steamers in the World' and 'Olympic and Titanic each 45,000 tons'.

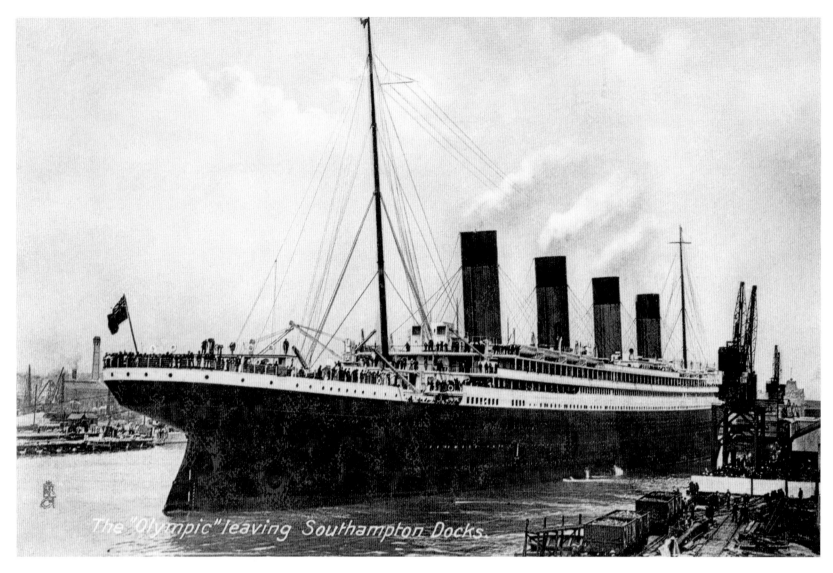

The "Olympic" leaving Southampton Docks.

Olympic backs out of her Southampton berth on 14 June 1911 at the start of her maiden voyage to New York. Note the work continuing on the dock, bottom right. (Tuck's Oilette)

Presenting a magnificent profile, *Olympic* proceeds down Southampton Water. The card was posted from Southampton on 18 March 1917 with the message: 'This ship I am sending you is sunk so you will never be able to see it now.' German First World War propaganda perhaps?

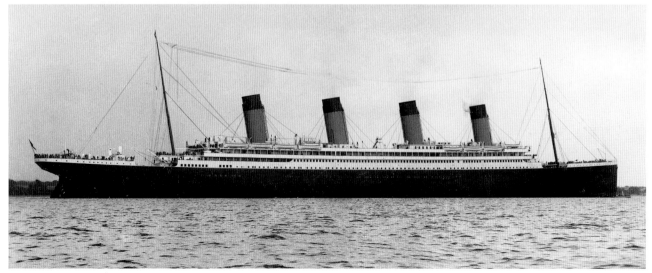

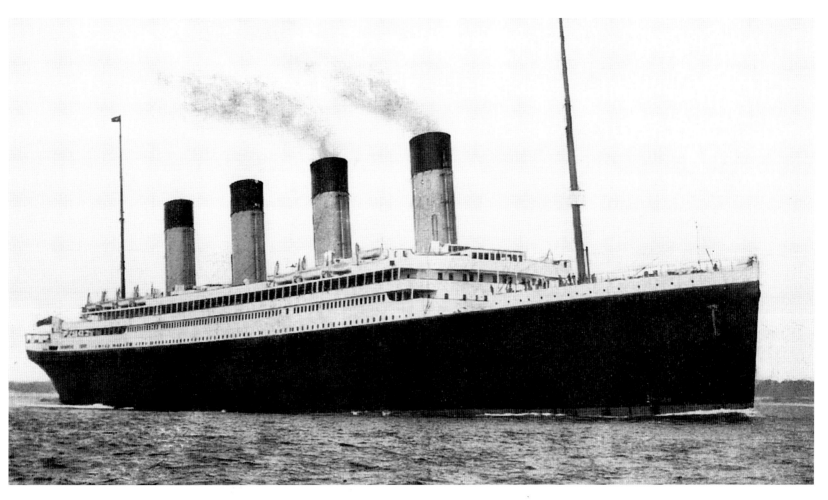

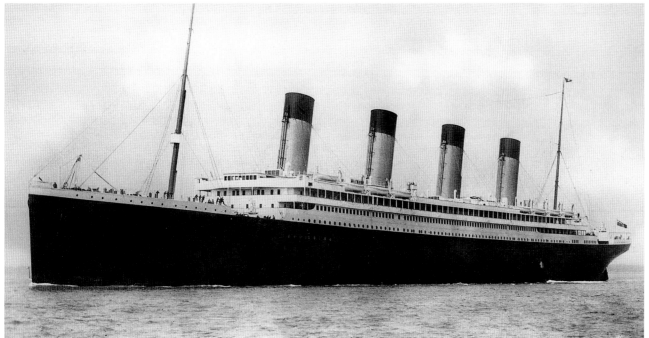

At the time this photograph of *Olympic* in Southampton Water was taken, both she and *Titanic* were almost identical in design. The decision to enclose *Titanic*'s forward first-class promenade deck had yet to be made.

No need now for artists' impressions as this classic photograph shows. (Davidson Bros)

The 473-seat capacity third-class dining room was located amidships and the pine-clad 'general room', with teak furniture, was aft on the starboard side. Opposite, on the port side, would be found the oak-panelled smoking room.

The open promenade area for third class was allocated aft on the poop (stern) deck and the enclosed forward section of 'D' deck.

Many of the manufacturers whose products were to be used on *Olympic* featured the vessel in their advertising at the time.

As the departure date drew near, *Olympic*'s crew of 860, of which 475 were catering staff, had all arrived and began familiarising themselves with the giant vessel. The two Marconi wireless operators and the eight members of the ship's band would travel as second-class passengers. The band would often split into two groups of five and three and play in separate areas of the ship, including the first-class grand staircase on the boat deck, the reception room and the second-class companionway. Third-class passengers were provided with a piano for their own entertainment.

Amongst the officers and crew were Purser McElroy, Dr O'Loughlin, First Officer Murdoch, Chief Steward Latimer and Chief Engineer Bell. Sadly all were to lose their lives the following year on *Olympic*'s sister ship *Titanic*.

Riding high out of the water, this photograph of *Olympic* on her trials has been heavily doctored. (W.E. Walton)

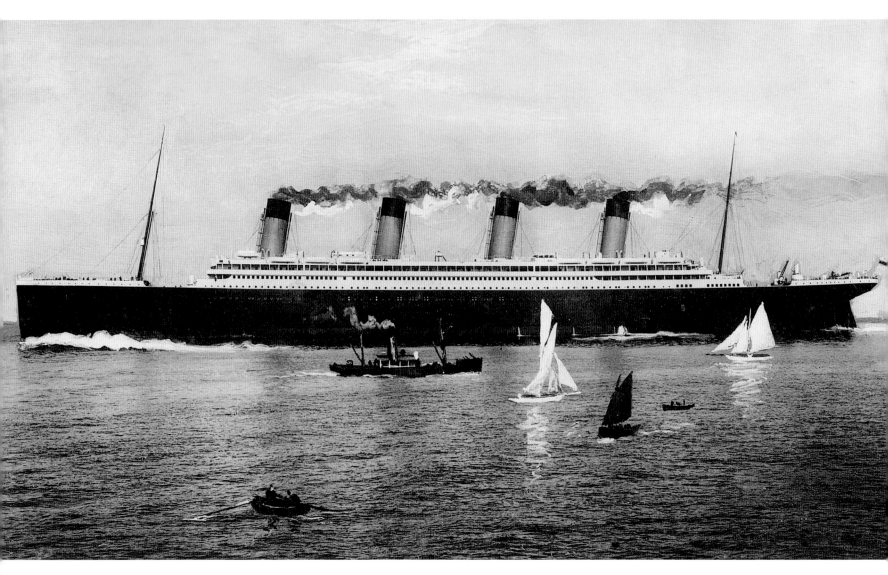

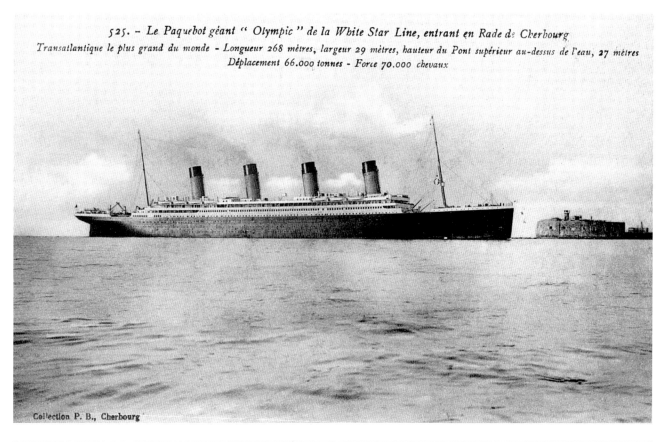

525. - Le Paquebot géant " Olympic " de la White Star Line, entrant en Rade de Cherbourg
Transatlantique le plus grand du monde - Longueur 268 mètres, largeur 29 mètres, hauteur du Pont supérieur au-dessus de l'eau, 27 mètres
Déplacement 66.000 tonnes - Force 70.000 chevaux

Collection P. B., Cherbourg

Olympic enters the Rade at Cherbourg. The tenders *Nomadic* and *Traffic* await her arrival.

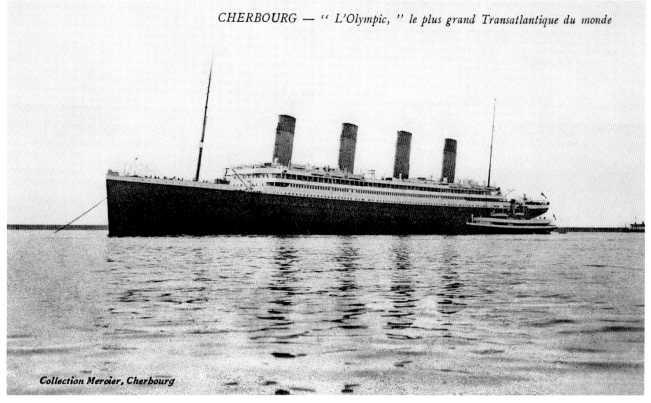

CHERBOURG — " L'Olympic, " le plus grand Transatlantique du monde

Collection Mercier, Cherbourg

Olympic anchored at Cherbourg with the smaller tender *Traffic* in attendance. The card was posted at Portsmouth on 11 September 1912. (Mercier)

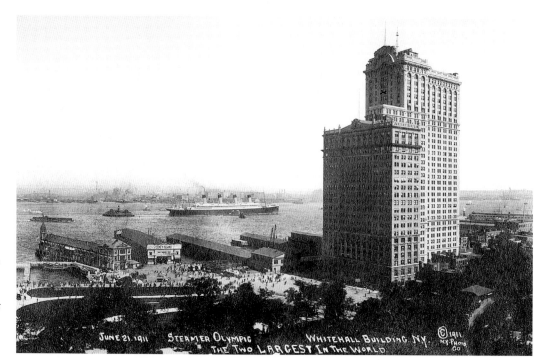

The world's largest liner enters New York at the end of her maiden voyage. (NY Photos Co./Private Collection)

The three tugs have been minimised to enhance the giant *Olympic* and her name on the port bow has been over-emphasised. This card was posted at Southampton on 14 September 1912 with the message: 'Arrived safe this afternoon had a very good passage.'

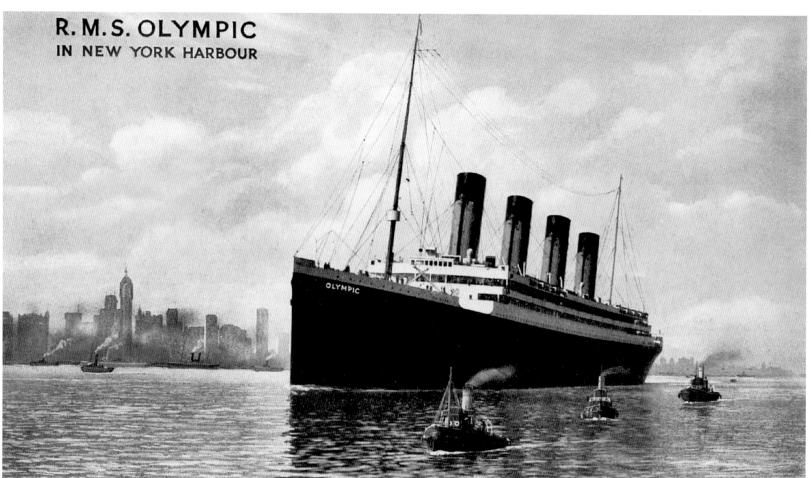

In command of *Olympic* for her maiden voyage was Captain E.J. Smith. He had commanded the first voyages of most of the recent White Star liners, including *Baltic* and *Adriatic*, and would earn a bonus of £200 per year 'if no ship under his command was involved in an accident'.

On Wednesday 14 June 1911, to the sound of crowds of cheering people and a band playing on the pier, the world's largest liner backed away from her berth to begin her maiden crossing of the Atlantic to New York. She was carrying 489 first-class passengers, among whom were the Chairman of IMM Mr J. Bruce Ismay, his wife and, Chief Designer and Managing Director of Harland and Wolff, Mr Thomas Andrews. Additionally, 263 passengers travelled in second class with 561 in third.

After calls at Cherbourg and Queenstown, and a crossing of five days, sixteen hours and forty-two minutes recorded between Daunt's Rock and the Ambrose Channel lightship, *Olympic* arrived at White Star Line's Hudson River Pier 59, at the end of Manhattan's West 19th Street, on 21 June. She had maintained an average speed of 21.17 knots with a daily coal consumption of 650 tons. In order to conserve fuel the five single-ended boilers had not been ignited. Interestingly, despite there being many salutes from vessels in port at the time, she was ignored by Cunard's *Lusitania*. It is thought that *Lusitania*'s captain was busying himself with her departure and had overlooked *Olympic*'s arrival.

Upon her arrival in New York *Olympic* was involved in an incident, which occurred on at least two more impor-

Back at Southampton, *Olympic*'s impressive starboard bow. (Nautical Photo Agency)

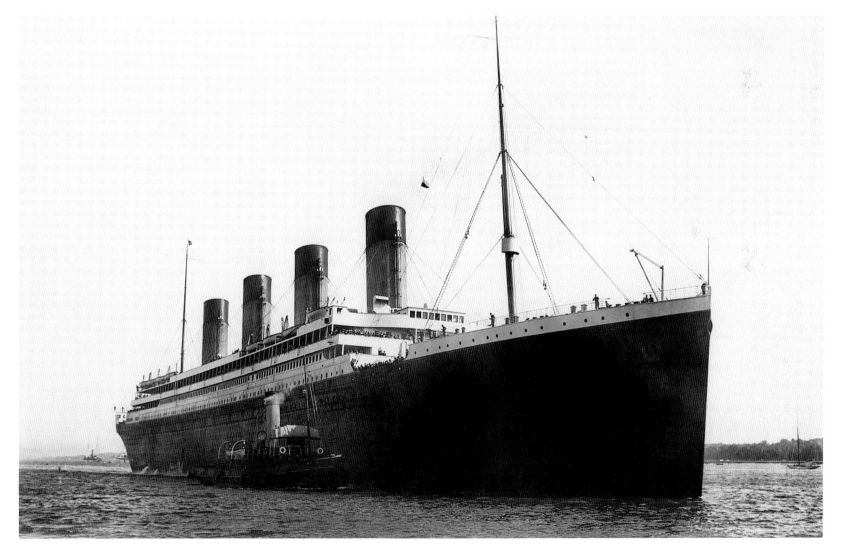

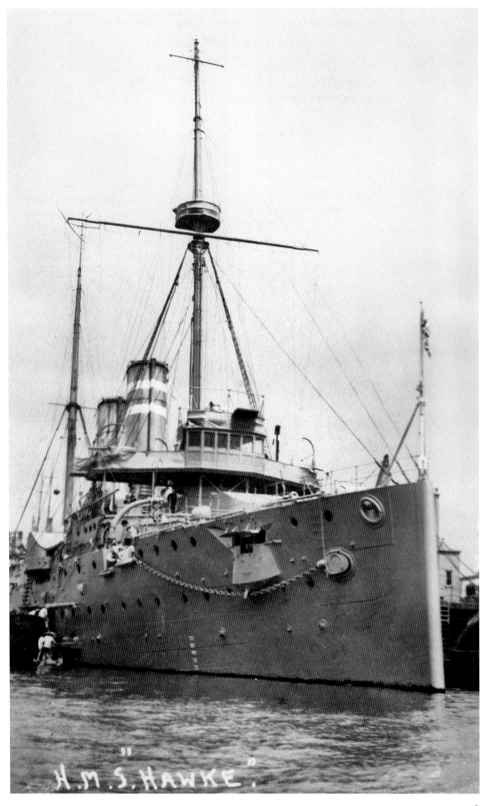

The Royal Navy's Edgar-class cruiser HMS *Hawke*. The calm waters conceal the deadly ram at her bow. (C. Cozens)

tant occasions, when the suction caused by her propellers and displacement dragged the tug *O.L. Hallenbeck* into her side, causing severe damage to the tug's stern.

After the arrival Bruce Ismay cabled Lord Pirrie: 'Olympic is a marvel and has given unbounded satisfaction.'

For seven days *Olympic* remained at New York during which time she was visited by the press, representatives of the travel industry, dignitaries and members of the public. White Star Line was eager to show off the latest addition to their fleet and, on the second evening of the stay, held a dinner on board for over 600 of their agents in the USA. The eastbound maiden voyage commenced on 28 June. Carrying many more passengers – 731 first class, 495 second and 1,075 third – *Olympic* arrived in Southampton on 5 July having maintained an average speed of 22.3 knots using all her twenty-nine boilers. On this one journey alone it was estimated that *Olympic* had earned her owners over £15,000. J. Pierpont Morgan of IMM and Lord Pirrie of Harland and Wolff both travelled on *Olympic*'s next westbound voyage.

Vice President Franklin, of IMM in New York, was to press continually for a Tuesday evening arrival in New York instead of the advertised Wednesday morning, but this never became established custom despite the occasional early arrival.

Having successfully completed four return crossings, *Olympic* arrived in Southampton on 16 September and prepared for her fifth departure on 20 September 1911. With Captain Smith and mandatory Pilot Captain George Bowyer on the bridge, *Olympic* departed Southampton at 11.25 a.m. and began to increase speed. The Royal Navy cruiser HMS *Hawke* (7,350grt), under the command of Commander William Blunt, was sailing towards the same channel in the Solent. She altered course to overtake on *Olympic*'s starboard side but was irresistibly drawn towards the giant liner, probably by a combination of water displacement and propeller suction. Whilst taking avoiding action, *Hawke*'s helm jammed 15 degrees to port and her ram impacted against *Olympic*'s starboard stern quarter. Captain Smith immediately stopped engines and closed the watertight doors. The collision had created a gash of nearly 42ft below the waterline near the second-class cabins on 'D' and 'E' decks. Fortunately most of those passengers had gone to their dining room for lunch.

Hawke, with collision mats over her damaged bow, slowly crawled back to Portsmouth.

Olympic anchored in Osborne Bay, Isle of Wight, to wait for high tide prior to returning to Southampton the following day to disembark her record number of 2,100 passengers and crew. She lay there for two weeks as the hole in her side was patched up. On 5 October, after a 570-mile three-day voyage at 10 knots, *Olympic* arrived back at Belfast for repairs, which were to last six weeks and cost over £100,000. She departed from there on 20 November to leave Southampton nine days later on her delayed fifth voyage. She had missed three return passages.

At the subsequent inquiry, surprisingly, *Olympic* was blamed despite *Hawke* being beyond the distance laid down by the Admiralty. White Star Line maintained that *Hawke*, as the overtaking vessel, had not steered out of *Olympic*'s way, her helm was too far over and her engines had not been reversed in time to avoid a collision, nor did she give the appropriate signals to indicate her manoeuvres. The Admiralty claimed that *Olympic* was in fact the crossing vessel and was to blame for not keeping out of *Hawke*'s way. It was found that *Olympic* had navigated too close to the cruiser and that her suction and displacement had drawn the warship towards her. White Star Line appealed as far as the House of Lords but to no avail. In 1918 on board *Olympic* her captain Bertram Fox Hayes is believed to have said: 'The Admiralty must have had the better lawyer as they certainly hadn't the better case.'

An artist's impression depicts the moment that HMS *Hawke* collides with *Olympic*. On the reverse of this card, posted at Queenstown in August 1913, Fred is telling his mother that he will bring some ironing when he comes home. Nothing changes!

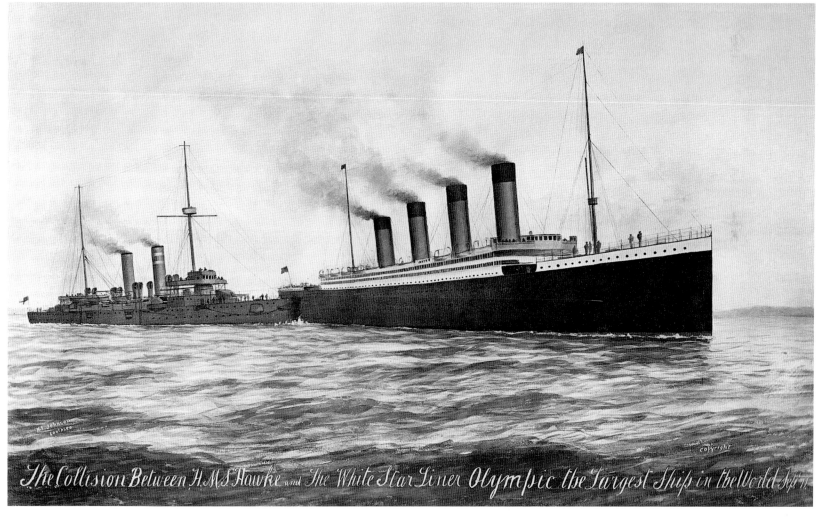

The Collision Between H.M.S. Hawke and The White Star Liner Olympic the largest Ship in the World Sep 11

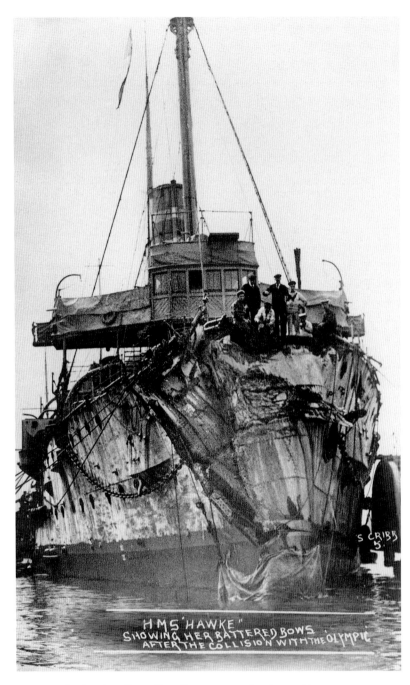

HMS *Hawke* after the collision. The collision mats over her shattered bow are clearly visible. (S. Cribb)

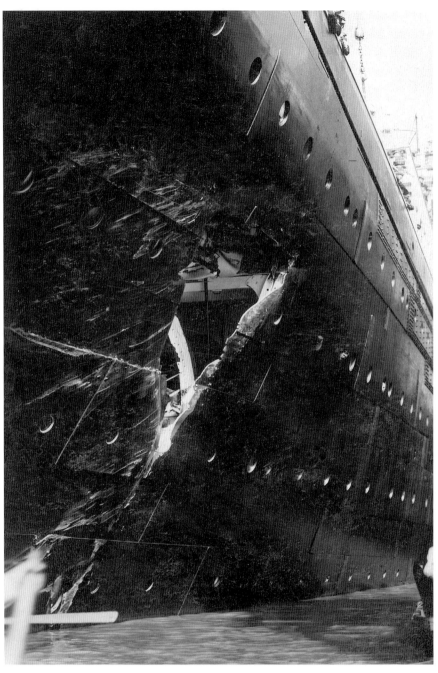

This photograph clearly illustrates the damage to *Olympic*'s second-class accommodation. Her passengers had gone to lunch so, thankfully, there were no fatalities caused by the collision. (A. Rapp)

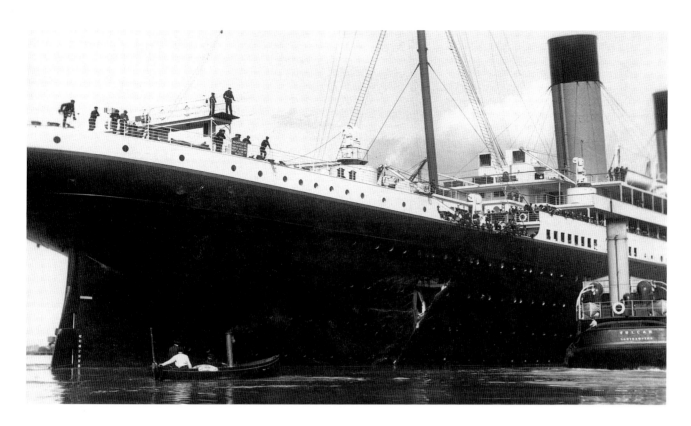

The tug *Vulcan* offers assistance as the collision damage is inspected. (A. Rapp)

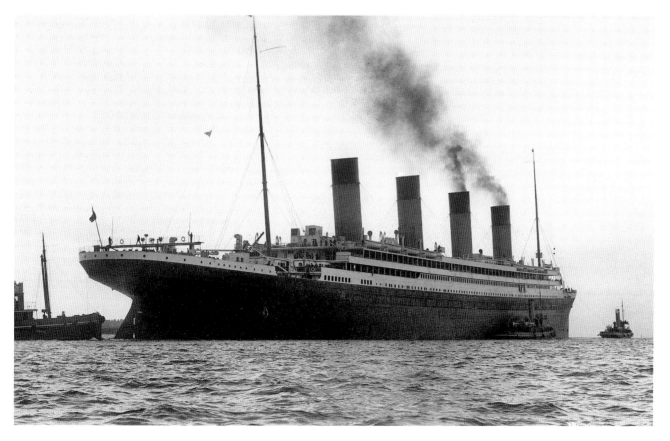

Olympic slowly makes her way back to Southampton. (A. Rapp)

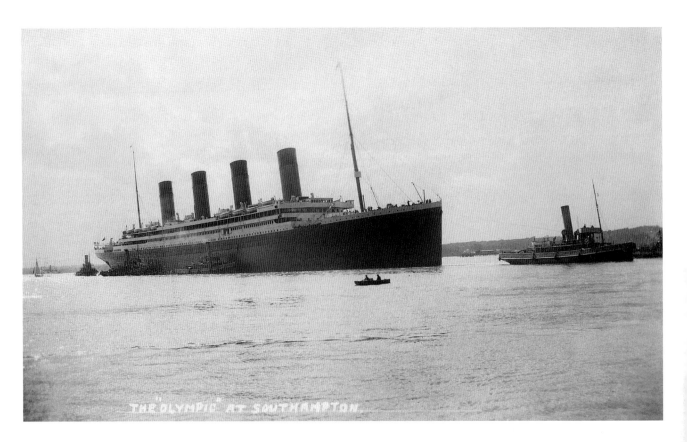

Assisted by tugs, the badly damaged *Olympic* approaches her recently vacated berth.

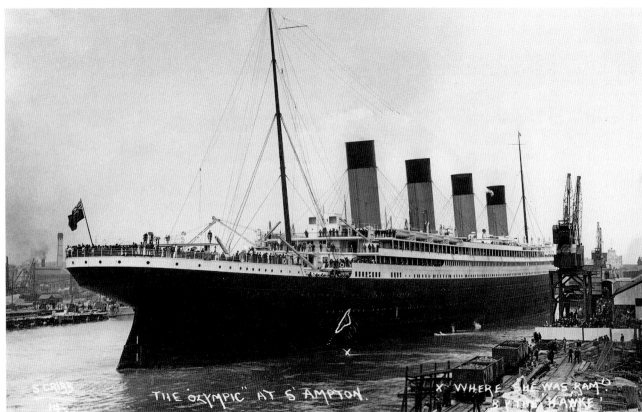

Olympic edges towards the White Star dock where she will disembark her passengers. The damaged area has been highlighted. (S. Cribb)

HMS *Hawke*, with more than 20ft of her bow replaced, was torpedoed and sunk in the North Sea, with great loss of life, by the German submarine *U9* on 15 October 1914. Interestingly, it is worth noting that Mr Gatti, in charge of the à la carte restaurant, and first-class passenger Harry Widener were on board at the time of the collision and both were to lose their lives the following year on *Titanic*.

White Star Line had issued their 1911/12 schedule on 18 September 1911 and it showed *Titanic* departing on her maiden voyage on 20 March 1912.

Olympic lost a port propeller blade on 24 February 1912, whilst returning from New York, and returned to Belfast for repairs on 1 March. Her 6 March Southampton departure was delayed until 13 March. Once again, men at Harland and Wolff were transferred from her sister ship, nearing completion, and *Titanic*'s maiden voyage was postponed until 10 April 1912. This was the last occasion on which the two vessels would be together.

White Star Line's *Olympic* lost her title 'Largest Steamer in the World' to Hamburg America Line's *Imperator* which, in 1913, was to become the first liner to exceed 50,000grt.

Straw boaters and cloth caps reflect the diversity of the spectators as *Olympic* approaches the quayside. (Silk)

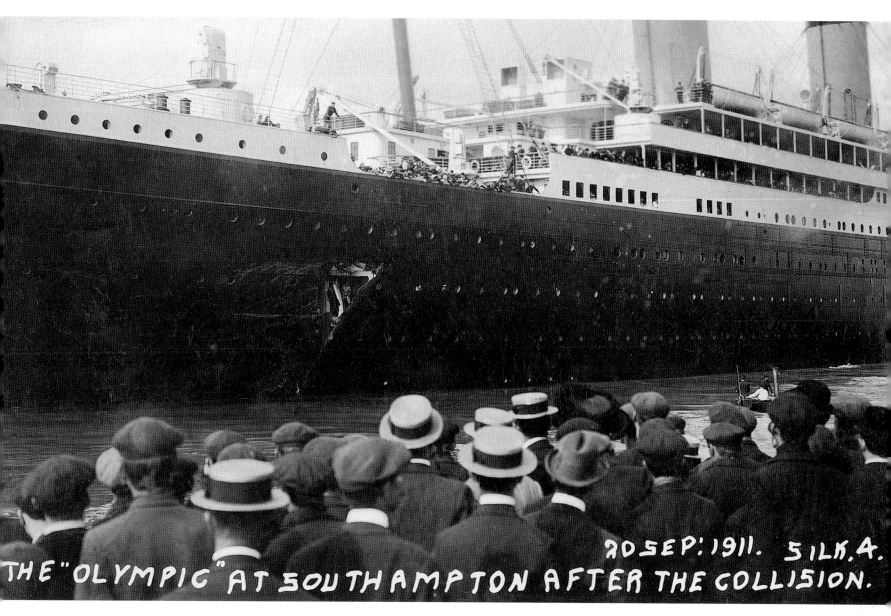

20 SEP: 1911. SILK. 4.

THE "OLYMPIC" AT SOUTHAMPTON AFTER THE COLLISION.

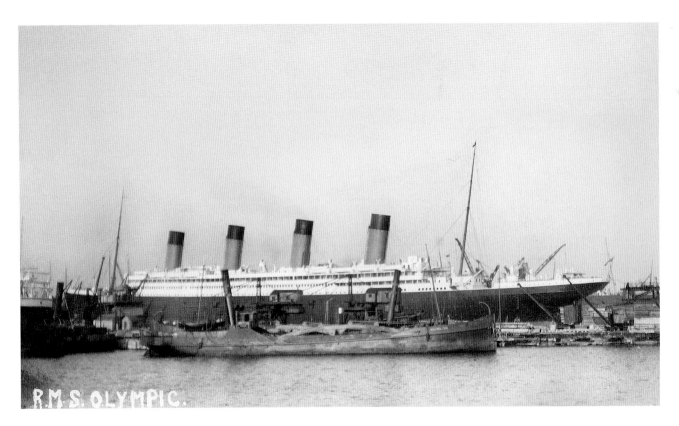

Back at Harland and Wolff, Belfast, the repairs to *Olympic* will take six weeks.

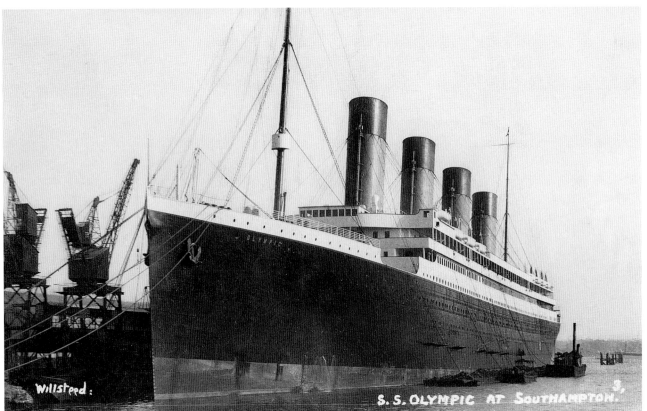

A magnificent view of *Olympic*'s port bow with her name clearly visible. This card was posted from Southampton in August 1912. (Willsteed)

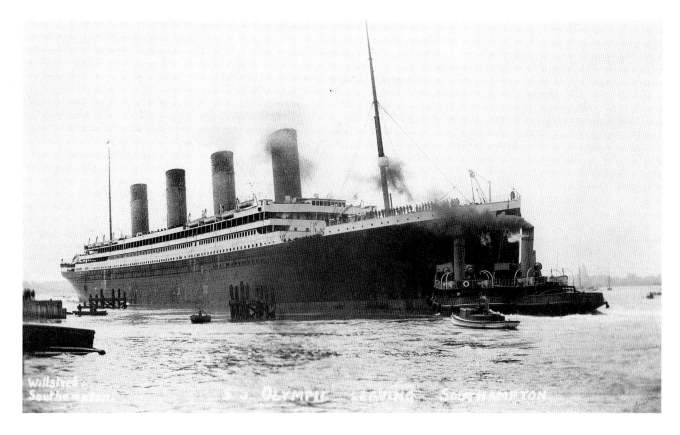

Tugs fussing at *Olympic*'s bow as she prepares to depart from Southampton. The message on the reverse is dated 29 June 1915 and reads: 'Just a few lines to let you know I have landed in Southampton allright but are leaving tonight for France we are only here for 9 hours.' From a member of the crew possibly? Note the line of crewmen on her deck. (Willsteed)

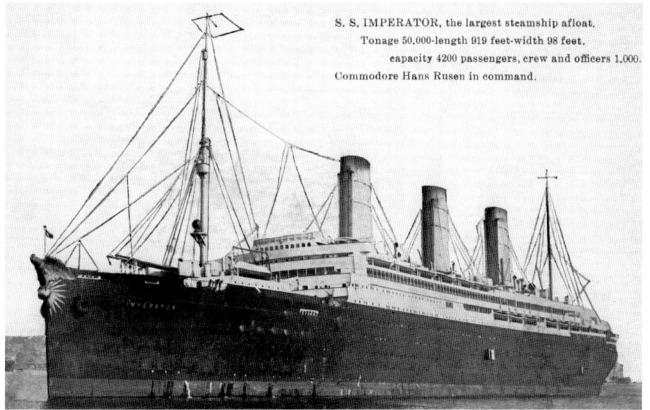

S. S. IMPERATOR, the largest steamship afloat.
Tonage 50,000-length 919 feet-width 98 feet.
capacity 4200 passengers, crew and officers 1,000.
Commodore Hans Rusen in command.

Germany's *Imperator* would steal the title 'Largest Steamship Afloat' from *Olympic* in 1913.

Minus the ornate eagle on her bow, *Imperator* slowly makes her way up the Hudson River to her New Jersey piers at Hoboken. (Rotary Photo)

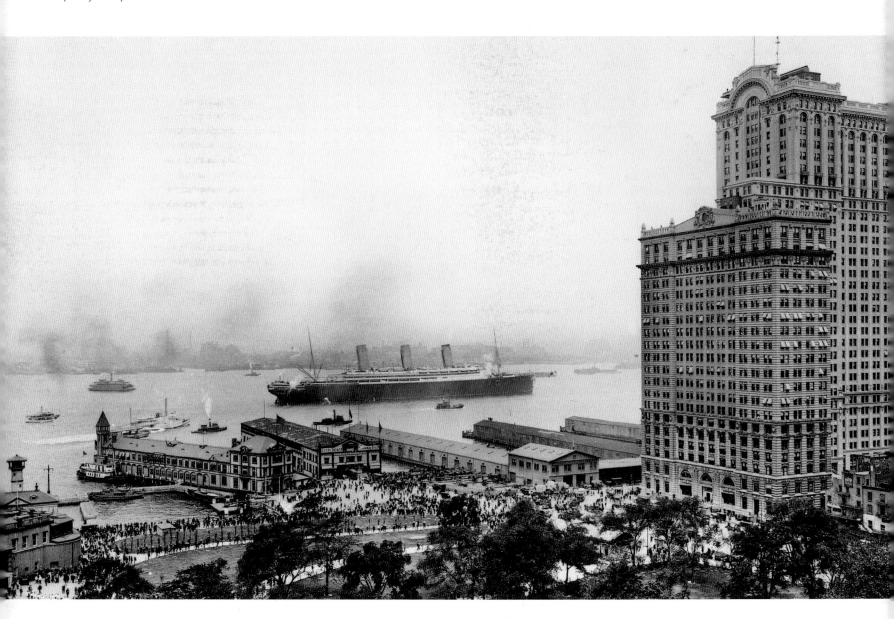

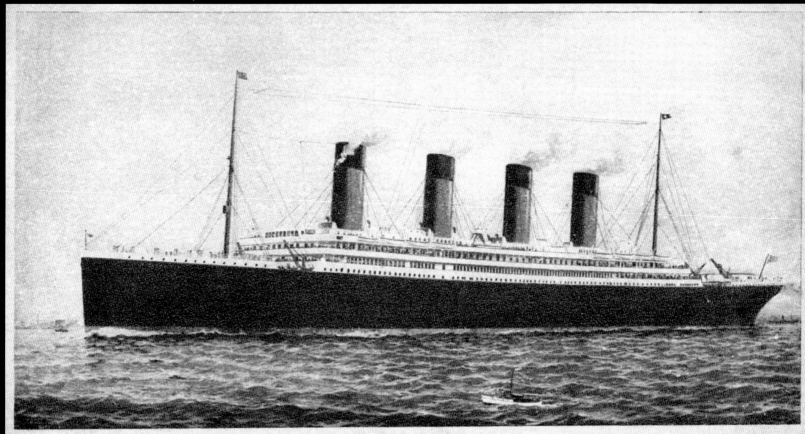

The Largest and Finest Steamers in the world
WHITE STAR LINE
"OLYMPIC" ☆ "TITANIC"
882½ FEET LONG 45,000 TONS REGISTER 92½ FEET BROAD

An American postcard depicting an artist's impression of the, at the time identical, proposed new super liners.

Amongst passengers on board *Olympic*, when she departed New York on 24 January 1912, were Mr J.J. Astor (one of the world's richest men), his young wife and Mrs Margaret Brown (later to become known as the 'Unsinkable Molly'). They were scheduled to return on *Titanic* for the delayed maiden voyage. Owing to a miners' strike in Britain, which ended on 6 April, the coal shortage was such that several liner departures from the UK were cancelled and extra coal was carried on *Olympic* on her New York departure of 23 March 1912.

Captain Edward J. Smith handed over command of *Olympic* to Captain Herbert Haddock on 30 March 1912 and assumed command of White Star's new *Titanic*. Haddock (age 51) had been appointed to *Titanic* as her captain on 25 March in order to familiarise himself with the Olympic-class liners. A popular but shy man, Haddock had previously been in command of *Oceanic* and was, like Smith, a member of the Royal Naval Reserve. *Olympic* departed Southampton on 3 April 1912, twelve hours before *Titanic*'s arrival in the early hours on Thursday 4 April, having left Belfast at just after 8 p.m. on 2 April. *Olympic* would arrive in New York on 10 April as *Titanic* commenced her dramatic maiden departure.

Ominously, whilst in command of *Adriatic* in 1907, Smith is reported as saying: 'I could not imagine any

Another promotional US card, this time comparing *Olympic* and *Titanic* with some of the world's tallest structures.

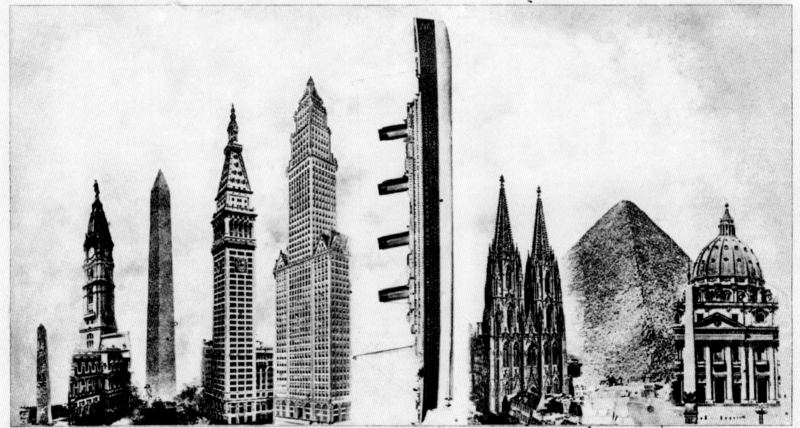

SURPASSING THE GREATEST BUILDINGS AND MEMORIALS OF EARTH

The White Star Line's New Triple-screw Steamers
"OLYMPIC" ☆ "TITANIC"
LARGEST AND FINEST IN THE WORLD
(SEE OVER.)

condition that could cause a ship to founder. I cannot conceive of any vital disaster happening to this vessel. Modern ship-building has gone beyond that.'

At noon on 10 April 1912 *Titanic*, assisted by eight tugs, departed Southampton for the start of her maiden voyage, bound for Cherbourg, Queenstown and New York. In an interestingly similar situation to her sister *Olympic* the previous year, the combined suction of *Titanic*'s propellers and her displacement of water dragged the stationary liner *New York*, the stern of which, having snapped its moorings, drifted towards *Titanic*. Captain Smith, assisted by Chief Officer Wilde and First Officer Murdoch, ordered *Titanic*'s engines stopped and

two of the tugs pushed *New York* out of danger. All three men were to lose their lives five days later. The most senior officer to survive the impending disaster would be Second Officer Lightoller.

At seven o'clock that evening *Titanic* collected further passengers at Cherbourg, delivered to her aboard the tenders *Nomadic* and *Traffic*. Having travelled overnight, *Titanic* embarked her final passengers at the Irish port of Queenstown around 12.30 p.m. Mercifully, as it turned out, *Titanic* was not full when she headed out into the Atlantic that Thursday afternoon. The exact figures vary but it is believed that first class was booked to 46 per cent capacity, second class to 40 per cent and third to

This card, posted on 14 July 1911, shows *Titanic* just after her launch. Later that day, *Olympic* departed Belfast for Liverpool and Southampton. (Real Photo Series)

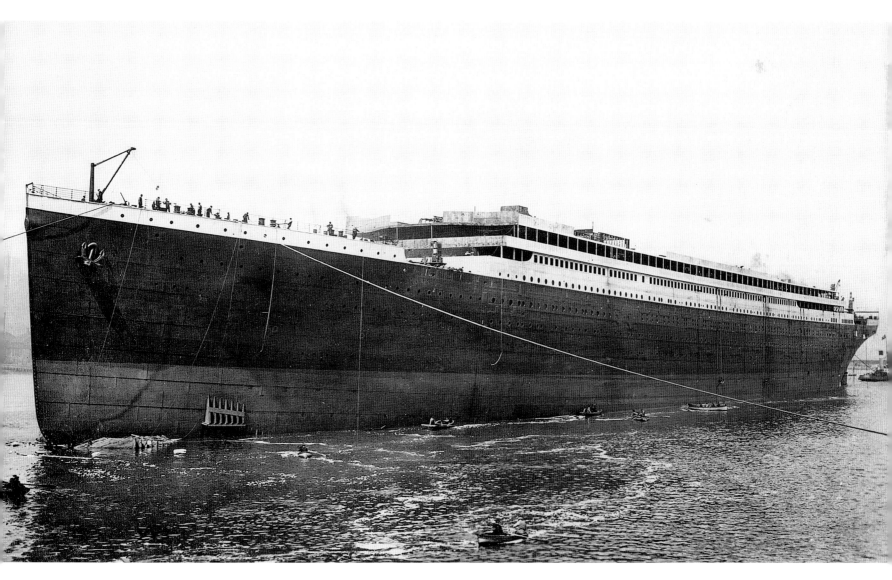

70 per cent. The approximate number of passengers carried was 1,320 and with her crew the total number of souls aboard was 2,212. Amongst her passengers was J. Bruce Ismay, the Chairman of White Star Line, and Thomas Andrews, the Managing Director of Harland and Wolff, leading an inspection crew for the maiden voyage.

On Sunday 14 April *Titanic* was approaching the Grand Banks on an international course which had been moved south to avoid ice and fog. During that day ice warnings had been sent by wireless from Cunard's *Caronia* and *Carpathia*, as well as White Star's own *Baltic* and Hamburg America Line's *Amerika*. Ice was reported as being much further south than usual for that time of year. One of the last warnings to be received was from Atlantic Transport's *Mesaba* at 9.40 p.m., reporting a number of large icebergs sighted in the area directly ahead of *Titanic*, which was

still proceeding at a nearly full speed of 21 knots. Her lookouts were told to keep a sharp eye out for ice. By 9.45 p.m. the sea temperature had dropped to freezing and pack ice was expected. At 11 p.m. Leyland Line's *Californian* radioed *Titanic* to say that she was stopped in an ice field. Senior Marconi operator Jack Phillips on board *Titanic* was still busy with passengers' personal messages and requested that *Californian* clear the airwaves.

Still at 21 knots, *Titanic* ploughed her course through the flat, calm sea. Had there been any kind of rough water an iceberg would have been visible at a greater distance as the waves broke at the base.

At 11.38 p.m. that Sunday, lookout Frederick Fleet, in the crow's nest on the forward mast, reported an iceberg directly ahead about half a mile away. On the bridge First Officer Murdoch ordered the helm 'hard-a-starboard',

Having lost a propeller blade in the mid-Atlantic, *Olympic* returned to Belfast where her sister *Titanic* (right) was still fitting out. This photograph reflects the last time that the two ships were together. (W.E. Walton)

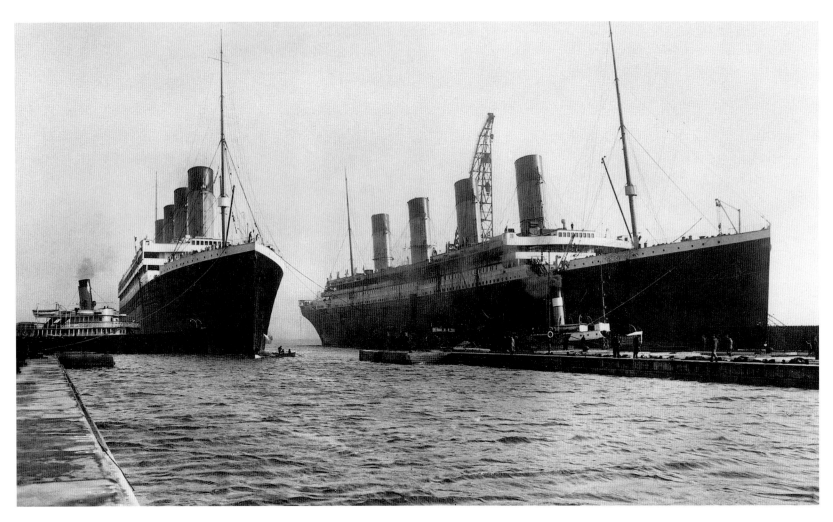

which in 1912 would have turned the bows to port. Still at maximum speed, however, with her bows only just starting to turn, *Titanic* struck the iceberg just aft of the foremast on her starboard side. Her hull was breached in several places opening up five of the watertight compartments to the sea. *Titanic* was doomed. Thomas Andrews, after a hurried inspection of the damage, estimated that *Titanic* had just over ninety minutes to remain afloat. There were lifeboats for 1,178 persons and yet more than 1,000 further souls were aboard.

Just after midnight on Monday 15 April the established distress signal of 'CQD' was sent out giving Titanic's position. This was later substituted with the recently agreed 'SOS'. Cunard's *Carpathia* was the nearest vessel to reply. She was 58 miles away and her captain, Arthur Rostron, radioed that she was making for *Titanic* as fast as was safely possible. Other vessels to reply were *Birma* (Russian American Line), *Frankfurt* (North German Lloyd), *Mount Temple* (Canadian Pacific) and *Virginian* (Allan Line).

Aboard the stationary *Californian*, wireless operator Cyril Evans had switched off and gone to bed at midnight,

just five minutes before the first distress message was sent from *Titanic*. He had finished his 'one-man shift'.

Olympic was on her twentieth crossing and carrying nearly 2,000 passengers, including the famous conductor Arturo Toscanini. She was over 500 miles from her stricken sister ship when the first distress message was received, just before midnight on 14 April ship's time: 'Tell Captain get your boats ready and what is your position?' *Olympic* replied: 'Commander Titanic 4.24 GMT 40 degrees 52 minutes North 61 degrees 18 minutes West. Are you steering Southerly to meet us? Haddock.' *Titanic* replied: 'We are putting passengers off in small boats.' It had been necessary for *Olympic* to request a pause in other vessels' transmissions as the airwaves had become overloaded with messages and it would be over half an hour before Haddock became aware of the seriousness of *Titanic*'s situation. He ordered an immediate change of course and increased speed to a record 23 knots; he also had the lifeboats uncovered and swung out. Less than an hour before *Titanic*'s foundering Haddock sent: 'Commander Titanic Am lighting up all possible boilers as fast as can. Haddock.'

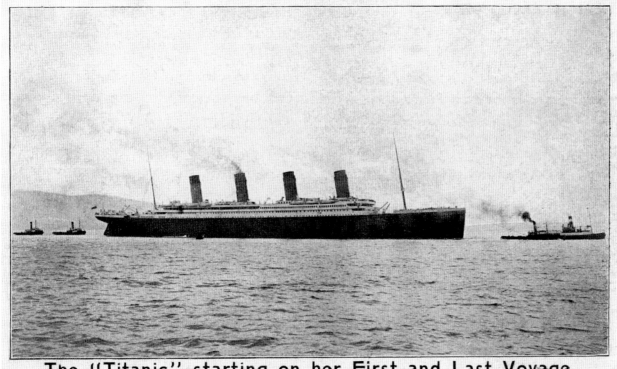

The "Titanic" starting on her First and Last Voyage.
On the way from Belfast to Southampton.

A souvenir card with statistics on the reverse. *Titanic* departs Belfast on 2 April 1912 for Southampton and history. Note the enclosed forward promenade deck making her instantly recognisable from her sister *Olympic*. (Solomon Bros)

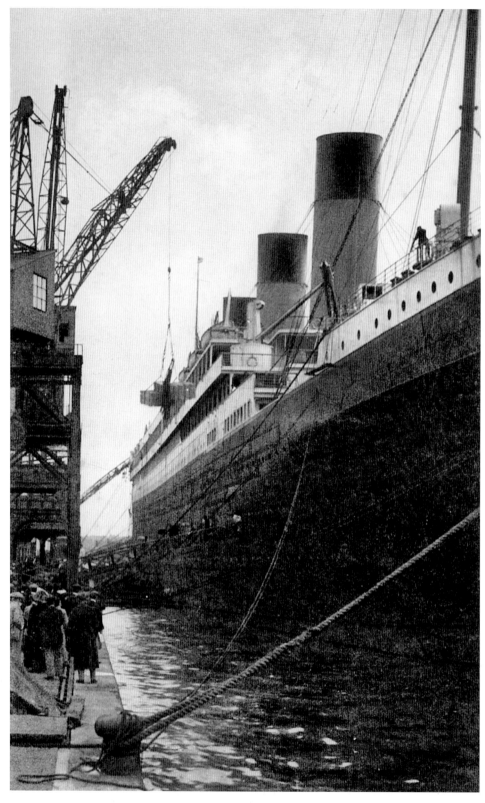

Olympic at Southampton. This picture, however, reflects almost exactly how her sister *Titanic* would have appeared as she prepared for her maiden departure. (R.B. Brown)

Olympic would have reached *Titanic*'s position twenty-four hours later.

The first of *Titanic*'s lifeboats, number seven, was lowered away around 12.30 a.m. only half full. Her passengers at first found it difficult to believe that this 'so steady' ship was actually sinking and were also unnerved by the 65ft drop to the sea. The seriousness of the situation became more apparent after 1 a.m. as *Titanic* began to settle by the head. By 1.30 a.m. the engine room had flooded and power was only available to the emergency lighting and wireless. The final distress rockets were fired at about 1.40 a.m. and the last lifeboat departed *Titanic* around 1.50 a.m. It was also around this time that *Olympic* heard for the last time from her sister. Over 1,500 persons remained on board, including 680 crew and over 100 women and 50 children. The sea temperature was freezing and life expectancy in the water was limited to minutes. At 2.20 a.m. *Titanic*, having broken in two on the surface, disappeared beneath the waves. Her last wireless message had been sent at 2.10 a.m. Sixty per cent of the first-class passengers survived, 44 per cent of second and 25 per cent of third class. Only 24 per cent of the crew had been saved.

On board *Olympic* senior wireless operator Ernie Moore radioed *Titanic*: 'What weather have you had?' 'Clear and calm' had been the reply. This would be the last direct communication between the two vessels as *Titanic*'s signals had become weak and ended suddenly. *Olympic* still clung to the hope that *Titanic* had suffered a loss of power but Haddock was becoming increasingly frustrated by the lack of news. There were no further replies despite *Olympic*'s continual requests for information. Finally, in the evening of 15 April, messages were received confirming the loss of *Titanic*. Over 700 survivors had been rescued by Cunard's *Carpathia*, amongst them J. Bruce Ismay. His message to Phillip Franklin, American Vice President of IMM, was intercepted by *Olympic* and forwarded to New York: 'Deeply regret advise you Titanic sank this morning after collision with iceberg, resulting in serious loss of life. Full particulars later. Bruce Ismay.'

Meanwhile, earlier that day in New York the press had begun to question Franklin as rumours about *Titanic* grew. Still unaware of the situation himself, he contacted *Olympic*

The American liner *New York* snapped her moorings and drifted towards *Titanic* as the giant liner left Southampton, causing a delay of nearly an hour.

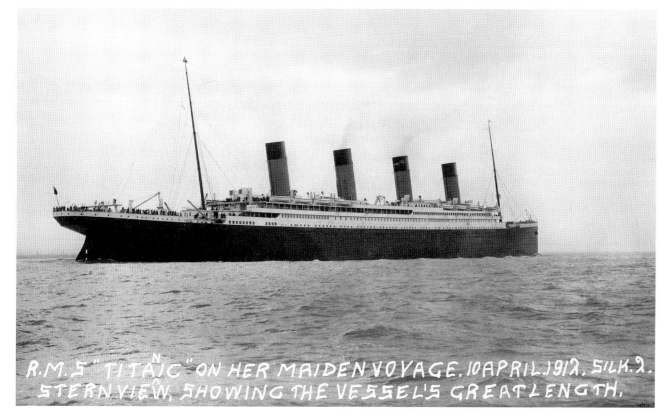

R.M.S " TITAN̂IC " ON HER MAIDEN VOYAGE. 10 APRIL 1912. SILK 2.
STERN VIEW, SHOWING THE VESSEL'S GREAT LENGTH.

Titanic heads towards the Isle of Wight and Cherbourg. The photographer, in his haste to get the postcard on to the market, had omitted the 'N' of *Titanic*! (Silk)

for news of her sister ship. She replied at 9 a.m. stating that she was still over 300 miles away and steaming at full speed to *Titanic*'s last radioed position. Despite Haddock's attempts to prevent news of the situation reaching his passengers, they awoke to discover that there had been a change of course during the night and that the lifeboats had been uncovered and swung out. Rumour began to spread amongst the passengers and crew to the extent that, at 12 noon, a bulletin was posted in *Olympic*'s public quarters stating 'New York reports all Titanic's passengers safe'.

Similar conflicting versions were also being reported in the US press. At 3.50 p.m. a message was received from *Carpathia*'s radio operator Harold Cottam telling of the receipt of the SOS, arrival at the scene, the rescue of about 670 souls in twenty lifeboats and that *Titanic* had sunk in about two hours. In addition the news spread that Captain Smith and all the engineers had been lost, but that two or three officers were on board and the second Marconi operator. Finally, it was divulged that J. Bruce Ismay had been rescued and was on board *Carpathia*. *Olympic* had steamed nearly 400 miles at full speed in vain.

The shock on board *Olympic* can only be imagined. A strange quiet fell over the ship and the usual routine on board was suspended. Many of the crew and passengers had had friends or relatives on *Titanic*. Captain Haddock offered to accept the survivors but *Carpathia*'s Captain Rostron considered it unwise for a nearly identical vessel to *Titanic* to be on the scene. Haddock then offered to continue the search for survivors but was advised by Rostron that there was no further hope as all lifeboats

The Cunard liner *Carpathia* was 58 miles from the sinking *Titanic* when the CQD was first received. (Harvey)

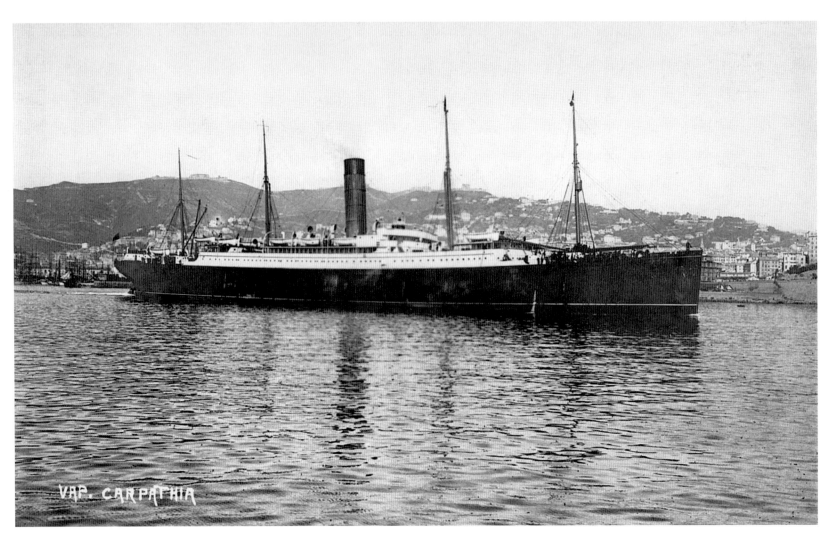

VAP. CARPATHIA

had been accounted for, *Titanic* had sunk at 2.20 a.m. and he was returning to New York.

Olympic and *Titanic* possessed the most powerful wireless equipment at sea and, as such, *Olympic*'s role now became that of messenger, during which time all personal messages were suspended. At 4.35 p.m. Haddock advised White Star, via Cape Race, of the loss of *Titanic* and loss of life, and that the Leyland liner *Californian* was continuing the search but *Carpathia* was returning to New York with about 670 survivors. Franklin received the awful confirmation at 6.20 p.m. EST. Rostron, on *Carpathia*, sent a private message to Haddock, on *Olympic*, that he had on board only the second, third, fourth and fifth officers from *Titanic* and that all other senior crew, including purser, chief steward, doctor and engineers had been lost.

Throughout this ordeal, *Olympic*'s chief Marconi operator, E.J. Moore, and his number two, A. Bagot, worked continuously taking turns at the wireless set. Upon returning to the UK Captain Haddock praised his two Marconi operators for their hard work.

By 8.45 p.m. *Olympic* began forwarding a partial list of survivors and the horrible loss of life was now becoming apparent. Haddock had withheld much of the information so, up until now, the passengers on *Olympic* had been unaware of the full situation. But on the evening of Monday 15 April bulletins were posted throughout the vessel containing the basic details of the disaster. A partial list of survivors was posted the following morning.

Franklin, in New York, had messaged *Olympic*: 'It is vitally important that we have the name of every survivor

One of many memorial postcards issued after the disaster, this one depicting Captain Smith and *Titanic* as she departed Southampton. (Harvey)

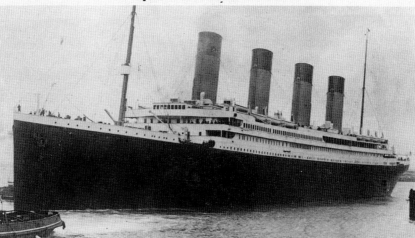

In Memoriam

to the OFFICERS, CREW and PASSENGERS numbering 1635 of the illfated Liner "TITANIC", wrecked on her maiden voyage from Southampton to New York colliding with an Iceberg in mid-atlantic 600 miles from land.

April 14th. 1912.

COMMANDER

E. J. SMITH, R.N.R.

BORN 1853,

HIS LAST WORDS WERE

"BE BRITISH",

JUST BEFORE THE

LINER SANK

ON THE MORNING

OF APRIL 15TH. 1912.

BRITISH HEROES

THE

BRAVE BANDSMEN

PLAYING

"NEARER MY

GOD TO THEE",

WHIL'ST THE

SHIP WAS

SINKING

ABOUT 2 A.M.

MONDAY

APRIL, 15TH. 1912.

R.M.S. TITANIC.

THE LARGEST VESSEL IN THE WORLD LEAVING SOUTHAMPTON, APRIL 10TH. 1912.

Published by Tom Harvey, Redruth.

on Carpathia immediately. Keep in communication with Carpathia until you accomplish this.' At 8.25 p.m. *Olympic* asked *Carpathia* if the list of the remaining third-class passengers and crew was now ready for transmission. 'No, will send them soon' was the reply.

At 9 p.m. in New York a tearful Franklin admitted that *Titanic* had sunk with terrible loss of life. *Olympic*, with her powerful radio, had relayed *Carpathia*'s messages to the US mainland during 16 April. Now, as the distance between the two ships increased, she resumed her course, having remained almost stationary throughout that Tuesday. Only 322 names of survivors had been forwarded and 'censored' personal messages were now permitted. The ship's orchestra did not play for the remainder of the voyage, but this only contributed to the aura of gloom that had settled on board *Olympic*. A committee was formed on board and over £1,400 was raised towards the Titanic Relief Fund.

With her flags at half-mast, *Olympic* arrived at Plymouth at dawn on 20 April, two days after *Carpathia*'s

arrival at New York, and finally at Southampton a day late at 2 a.m. on 21 April. Only when the British newspapers became available were *Olympic*'s passengers aware of the full details of the disaster. Many were annoyed at the withholding of information and even more so when they learnt of the inadequate lifeboat provision.

Before the turn of the century the British Board of Trade had decreed, in the Merchant Shipping Act of 1894, that all vessels over 10,000 tons should carry at least sixteen lifeboats. No amendment had been made to this figure by 1912 despite the fact that ships had grown to over 45,000 tons, as in the case of *Olympic* and *Titanic*. Most British-registered vessels, including those belonging to Cunard (*Mauretania* with a capacity of 2,972 carried lifeboats for only 962 persons), carried insufficient lifeboats. There now followed a desperate demand throughout the industry for additional boats. The Merchant Shipping Act was amended on 1 January 1913 to ensure that there would be sufficient lifeboats for all on board.

White Star triple-screw Steamer "Titanic" 45000 tons.
This and the sister ship "Olympic" 45000 are the two largest vessels in the world.
Wrecked on April 15th. **1635 Lives Lost.**

Details of the disaster have been added to this card depicting *Olympic* at Liverpool. The number of lives lost was later revised to approximately 1,500.

Olympic departed Southampton on 24 April 1912 carrying twenty-four additional Berthon collapsible lifeboats. Forty boats had been available, it is believed from naval vessels, but only twenty-four were required. It is thought that, witnessing the offloading of the surplus boats, many of the stokers assumed they were not seaworthy and refused to sail, saying conventional wooden boats would have to be supplied.

Faced with the prospect of nearly 300 stokers refusing to work, White Star Line postponed the departure after moving *Olympic* to an anchorage in the Solent. Over 160 replacement stokers were hired in Sheffield, Liverpool and Portsmouth, whilst union representatives witnessed several of the new boats being successfully lowered and raised. Having satisfied the unions, a tug arrived with the new hires around midnight. Now fifty-three seamen refused to sail, as they considered that the newly arrived crew was not only non-union but lacked experience. These seamen departed *Olympic* on the returning empty tug.

An exasperated Haddock called on the Royal Navy's cruiser HMS *Cochrane* with the message 'Crew deserting ship, request your assistance, Haddock, master'. Despite the assistance of *Cochrane*'s captain Goodenough the 'mutineers' would not return to *Olympic*. Even though thirty new seamen had arrived by tender the next morning, White Star Line decided to cancel the voyage.

Nearly forty-eight hours after departing, *Olympic* returned to the White Star dock in Southampton to disembark her passengers, most of whom were transferred to *Lusitania* at Liverpool or German liners in either Southampton or Le Havre. Her next departure would be on 15 May, with union approval but with only 432 passengers. White Star Line took the 'mutineers' to court and they were found guilty. The judge, however, decided not to punish them owing to the 'special circumstances created by the loss of the Titanic'.

As a final footnote to the sinking of *Titanic*, Senator Alden Smith of Michigan, Chairman of the American Congressional Committee investigating the loss, made a surprise visit to *Olympic*, on Saturday 25 May, as she lay over after her arrival at New York. After witnessing a demonstration of the life-saving equipment he was also given a copy of the wireless log covering the hours of the *Titanic* disaster. Additionally Lord Mersey, in charge of the

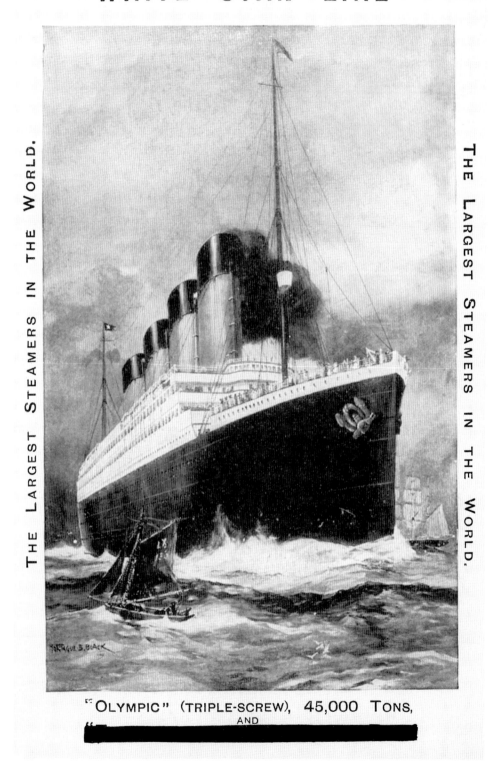

WHITE STAR LINE

THE LARGEST STEAMERS IN THE WORLD.

THE LARGEST STEAMERS IN THE WORLD.

"OLYMPIC" (TRIPLE-SCREW), 45,000 TONS,
AND

Titanic's name has been clumsily blacked out on this postcard but the plural word 'steamers' remains.

British inquiry, viewed the lowering of lifeboat number nine in Southampton on 6 May 1912.

Despite making six more return voyages after the loss of her sister, it became clear that serious alterations would have to be made to *Olympic* to restore public faith and the recommendations of both the US and UK inquiries would have to be accepted. White Star Line announced on 11 August that she would return to Harland and Wolff in October 1912 for a nearly six-month major structural and internal refit.

Five of her fifteen transverse bulkheads were raised to 'B' deck nearly 40ft above the waterline. An inner shell was created providing a double skin, such as already existed on Cunard's *Lusitania* and *Mauretania*, but whereas the gap between the skins on these two vessels was used to store coal, White Star Line chose to have this space on *Olympic*

remain empty. The changes now ensured that *Olympic* would remain afloat with six of her forward or aft compartments flooded whereas it had previously been four.

Twenty wooden lifeboats were ready and installed but thirty-two additional, decked, wooden lifeboats had been ordered. However, with the high demand for boats at the time, only sixteen were available and temporarily sixteen collapsible boats were supplied as replacements. Lifeboat capacity had now increased to over 3,500 from the previous 1,200.

As a result of *Olympic*'s passenger feedback, *Titanic*'s forward promenade 'A' deck had, at the last minute, been partially enclosed to prevent the effects of excess sea spray. The decision was made, however, not to change that of *Olympic*. White Star Line felt that, owing to so much deck space being taken up by the additional boats

Olympic, off the Isle of Wight, about to return to Southampton to disembark her passengers after the cancellation of her 25 April 1912 voyage. (Broderick)

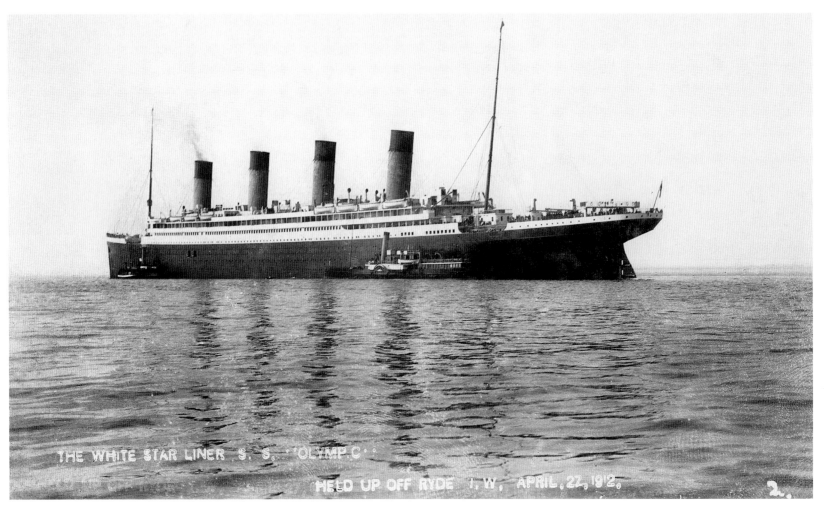

62

on the boat deck, much of the remaining sea view would be affected.

Internally a Café Parisien, very popular on *Titanic*, was installed starboard of the à la carte restaurant, with eighteen tables seating fifty-nine. The restaurant itself was extended across the width of the port side of the ship, thus increasing the capacity to 176 and the staff from fifty-two to sixty-eight.

Finally, on 22 March 1913, the 'new' *Olympic* departed Belfast. Her refit had cost over £250,000 of which over £150,000 had been spent on safety. Her gross tonnage had increased to 46,359 and she was now registered to carry 735 first-class passengers, 675 second and 1,030 third, totalling 2,440.

During *Olympic*'s winter absence White Star's express service was maintained by *Oceanic* and *Majestic*, the latter having been brought out of lay-up after the loss of *Titanic*. In addition, ships of the American Line, another IMM-owned company, were recruited to supplement the route.

Olympic departed Southampton for New York on 2 April 1913 carrying over 1,500 passengers.

J.P. Morgan died in Rome, aged 76, in March 1913 and control of IMM passed to his son, J.P. Morgan Jr.

J. Bruce Ismay retired from IMM and White Star Line in June 1913. His retirement had been announced several months prior to *Titanic*'s loss, and he was replaced shortly afterwards by P.A.S. Franklin as President of IMM.

The ageing *Majestic* was taken out of lay-up to fill the gap in White Star's schedule caused by the loss of *Titanic* and, later, by *Olympic*'s rebuild. (Rotary)

Heavily laden with lifeboats, *Olympic* is seen here departing Southampton in 1913. Note the German four-stacker on the left of the picture. (A. Rapp)

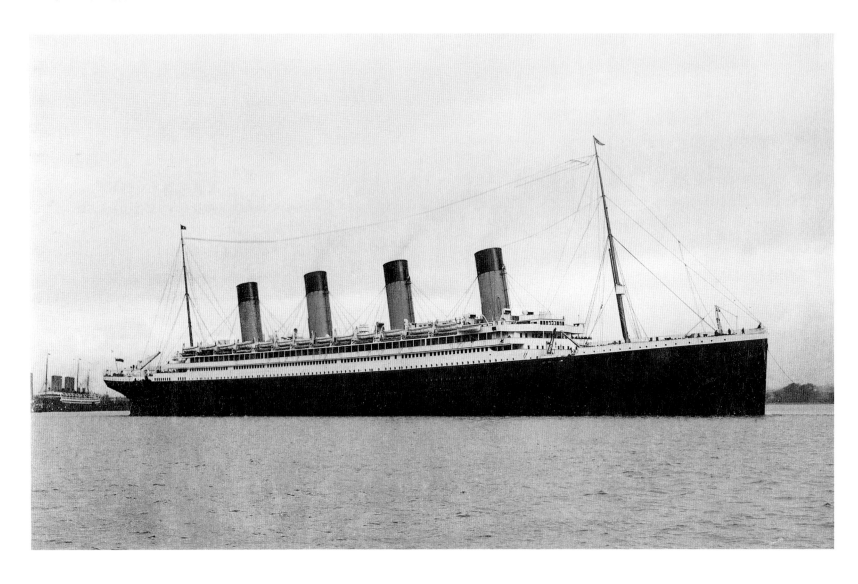

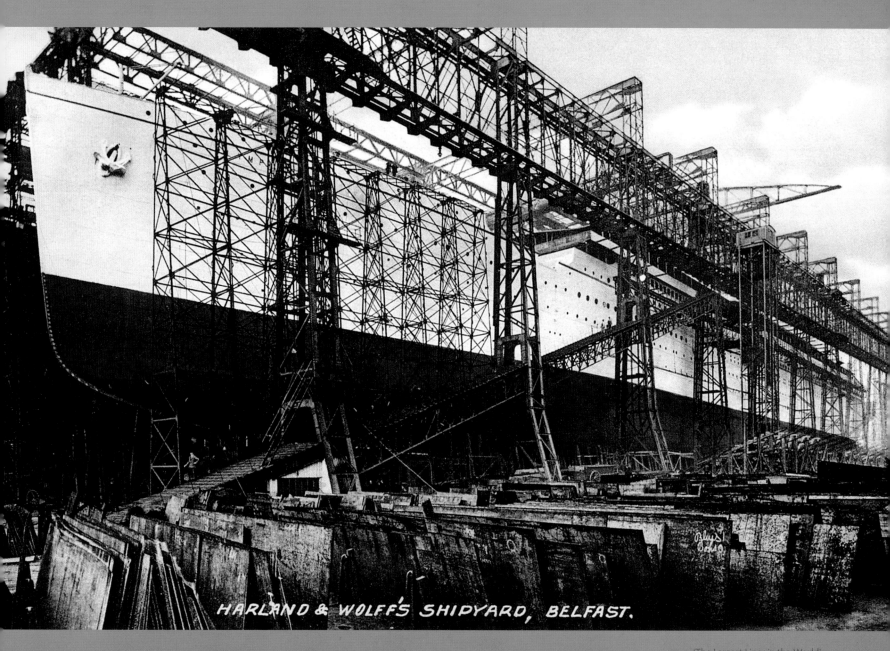

HARLAND & WOLFF'S SHIPYARD, BELFAST.

'The Largest Liner in the World',
ready for her launch and painted
light grey. (W.E. Walton)

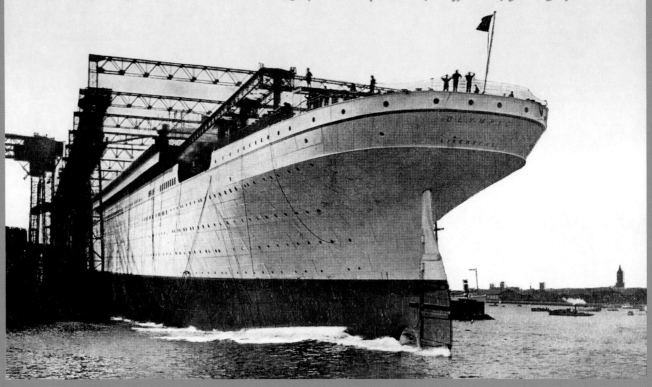

Launch of the Giant White Star Liner "Olympic" at Harland & Wolff's Shipyard, Belfast

Olympic takes to the water for the first time. She was stationary within two minutes. (W.E. Walton)

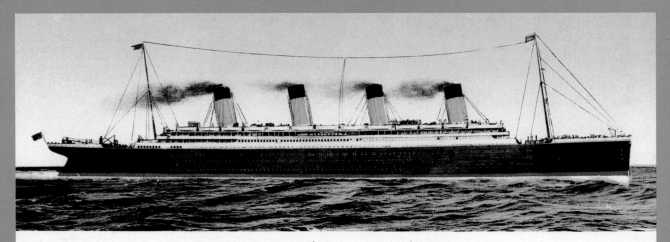

Despite the smoke incorrectly emitting from her fourth (dummy) funnel, and shown here with many more lifeboats than she actually carried at the time, this illustration nevertheless conveys the impressive beauty and symmetry of White Star's new *Olympic*. (John Adams)

THE NEW WHITE STAR LINER "OLYMPIC."

45,000 tons gross register. 66,000 tons displacement. Built by Harland & Wolff, Belfast ; launched October 20, 1910.
Accommodation, 2500 passengers and a crew of 860. Speed 21 knots. Estimated cost, £1,500,000.
The following are the dimensions, etc., of the great vessel :

Length over all	882 ft. 6 in.	Distance from top of funnel to keel	175 ft. 0 in.
Breadth over all	92 ft. 6 in.	Number of steel decks	11
Breadth over boat deck	94 ft. 0 in.	Number of water-tight bulkheads	15
Height from bottom of keel to boat deck	97 ft. 4 in.	Rudder weighs	100 tons.
Height from bottom of keel to top of captain's house	105 ft. 7 in.	Stern frame, rudder and brackets	280 tons.
		Each anchor	15 tons.
Height of funnels above casing	72 ft. 0 in.	Bronze Propellor	22 tons.
Height of funnels above boat deck	81 ft. 6 in.	Launching weight	27,000 tons.

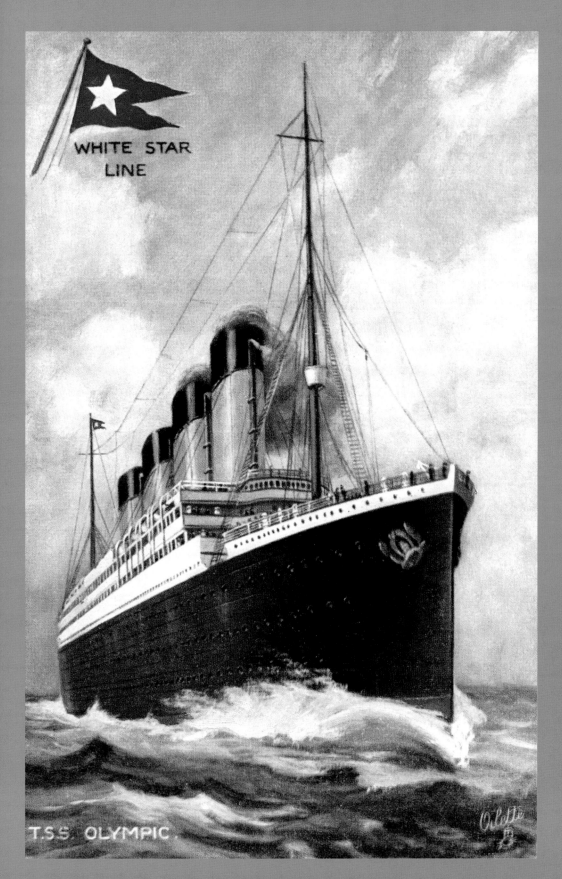

WHITE STAR
LINE

T.S.S. OLYMPIC

Oilette

An artist's impression of White
Star Line's new *Olympic*. The
reverse carries the words: 'RMS
Olympic is the largest vessel
afloat at the present time and is a
wonderful achievement of British
shipbuilding combined with the
enterprise of the owners.'
(Tuck's Oilette)

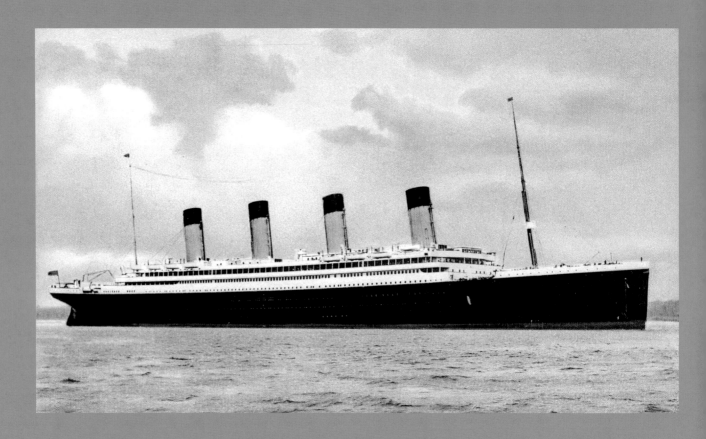

A superb colour-enhanced photograph of *Olympic*. The message on the reverse reads: 'We went over the Olympic Wed. morn. were on board over 2 hours. She is a great boat well worth seeing.' (F.G.O. Stuart)

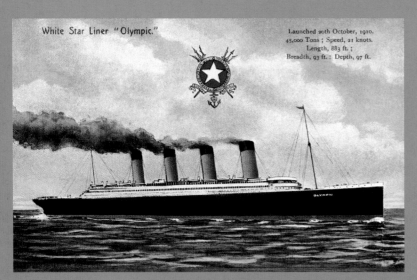

White Star Liner "Olympic."

Launched 20th October, 1910.
45,000 Tons ; Speed, 21 knots.
Length, 883 ft. ;
Breadth, 92 ft. : Depth, 97 ft.

Despite being a rather naive image, this postcard was sold on board
Olympic during her early years. (National Series)

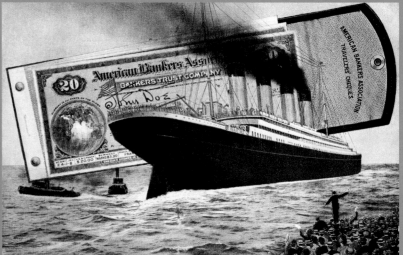

Olympic (or *Titanic*) was featured in this 1911/12 advertisement for
American Bankers Association Travellers Cheques. This card was issued by
the Third National Bank of Scranton Pa. and posted on 5 July 1912.

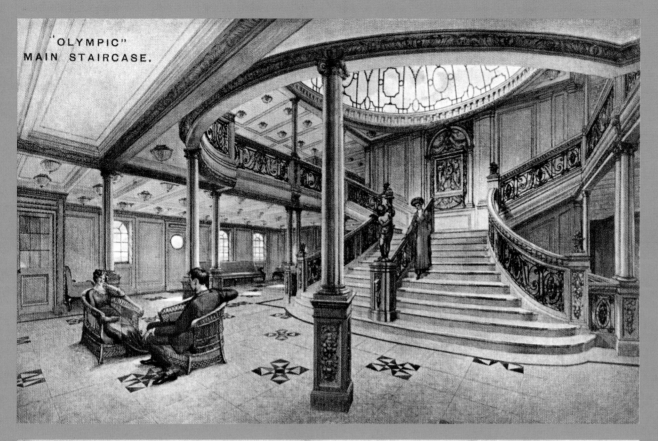

"OLYMPIC"
MAIN STAIRCASE.

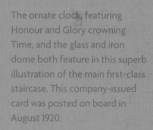

The ornate clock, featuring Honour and Glory crowning Time, and the glass and iron dome both feature in this superb illustration of the main first-class staircase. This company-issued card was posted on board in August 1920.

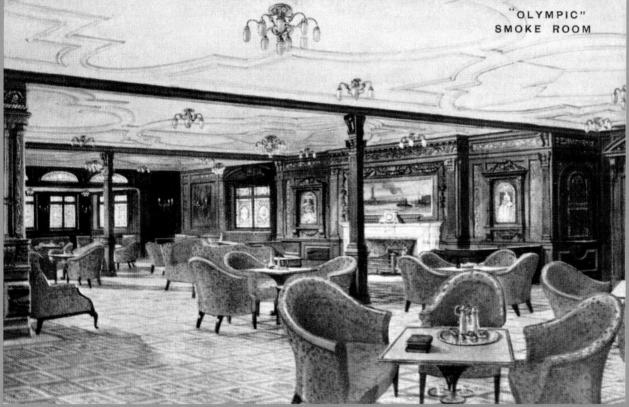

"OLYMPIC"
SMOKE ROOM

Another company-issued card, this time depicting the male enclave of the first-class smoking room. Norman Wilkinson's 'Approach to the New World' is clearly visible above the fireplace.

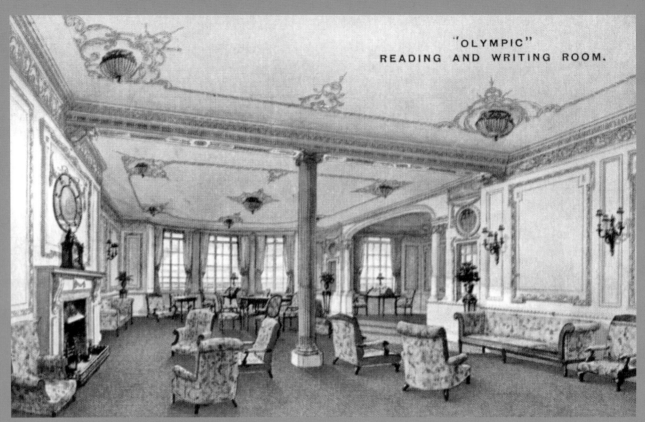

"OLYMPIC"
READING AND WRITING ROOM.

The elegant 'Reading and Writing Room', featuring a large bow window, became very popular with *Olympic*'s first-class ladies.

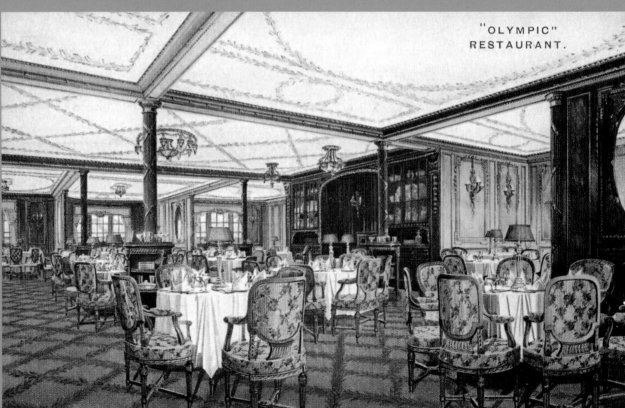

"OLYMPIC"
RESTAURANT.

Olympic's first-class à la carte restaurant on 'B' deck proved to be so popular that, after two return crossings, tables were increased from twenty-five to forty-one.

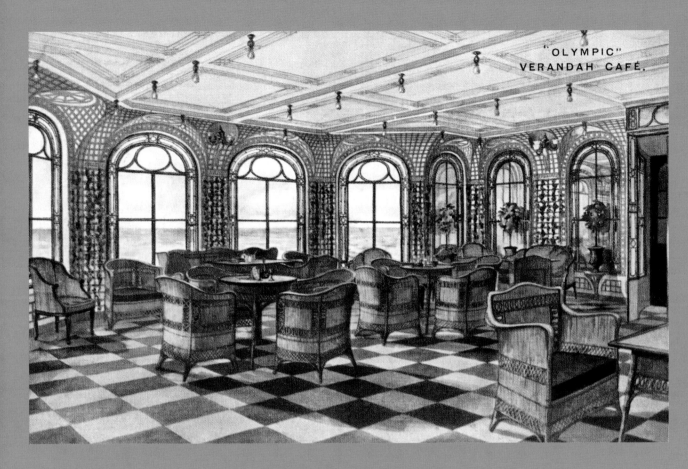

Olympic's first-class passengers could purchase light snacks here in the airy Verandah Café between 8 a.m. and 11 p.m.

Unlike her sister ship *Titanic*, *Olympic*'s parlour suites did not feature a private promenade. This card was posted on board on 26 May 1914.

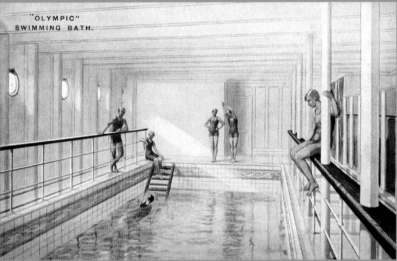

First-class ladies were permitted to use *Olympic*'s swimming pool, only the second afloat, between the hours of 10 a.m. and 1 p.m.

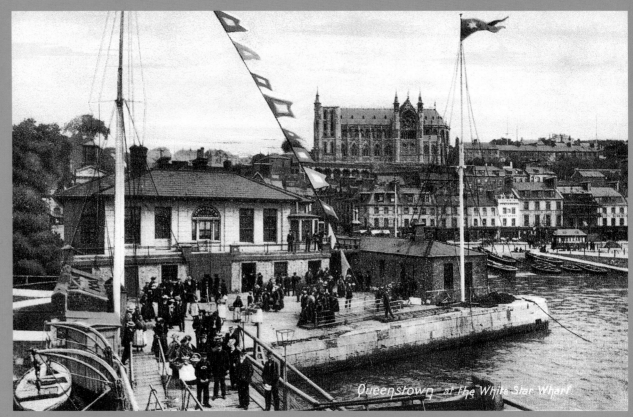

Passengers, predominantly emigrants, wait to board the tender at the White Star Wharf in Queenstown (now Cobh), Ireland. The cathedral's spire was added in 1913.

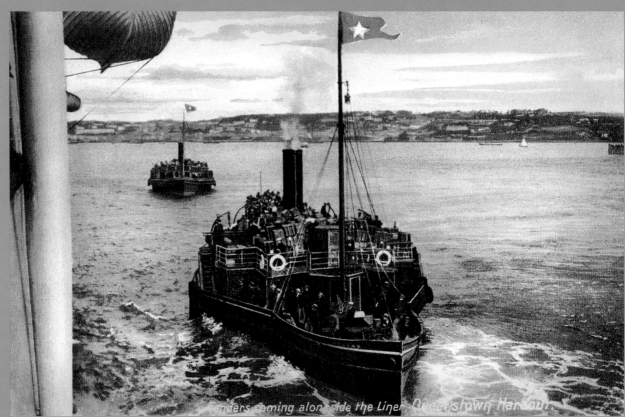

The paddle tenders *America* and *Ireland* approach a waiting White Star liner on this busy day at Queenstown.

WHITE STAR LINE

Triple-Screw R.M.S., "OLYMPIC,"

45,324 Tons
The Largest Steamer in the World.

Sails Southampton to New York. Wed. April 2nd.

The White-Star Line Triple-Screw Steamer "**Olympic**," 45,324 tons, the largest vessel in the world, is now at Belfast undergoing important alterations. These consist of the introduction of an Inner Skin, the increase of the number of Watertight Bulkheads, and the carrying of some of these latter higher up in the ship, thus augmenting the flotation capacity and enhancing the margin of safety provided in the "Olympic" far beyond all previously recognized standards. The "Olympic" will resume sailing from Southampton and Cherbourg to New York on Wednesday, April 2nd.

Southampton, 4th March 1913.

Two company-issued, post-*Titanic*, amended cards, each with the name '*Titanic*' removed and the word 'steamer' changed from the plural. Additionally, in blue print, the words 'Sails Southampton to New York. Wed. April 2nd' are printed. This refers to *Olympic*'s first sailing, in 1913, after major alterations in Belfast during the refit of 1912/13. Each card is dated, on the reverse, 'Southampton 4 March 1913' and carries the notice pictured.

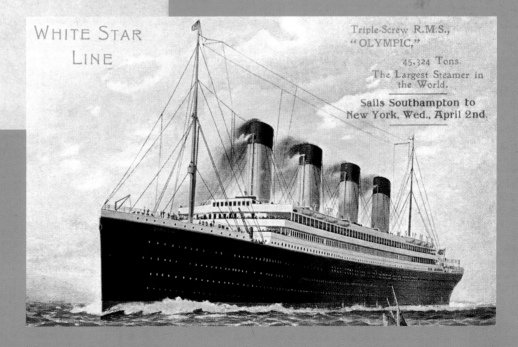

WHITE STAR LINE

Triple-Screw R.M.S., "OLYMPIC,"

45,324 Tons.
The Largest Steamer in the World.

Sails Southampton to New York. Wed., April 2nd.

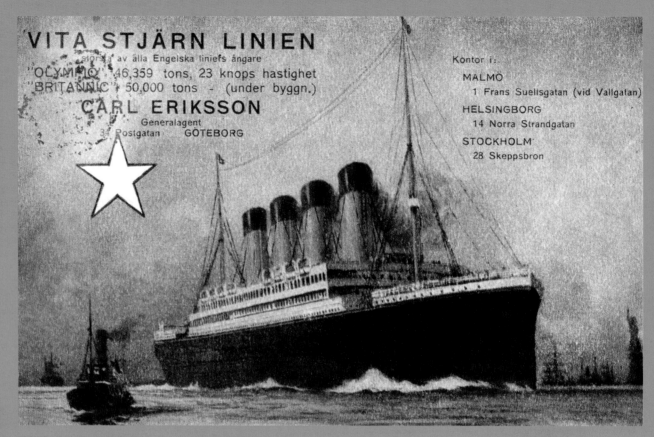

VITA STJÄRN LINIEN

av alla Engelska liniefs ångare

"OLYMPIC" 46,359 tons, 23 knops hastighet
"BRITANNIC" 50,000 tons - (under byggn.)

CARL ERIKSSON
Generalagent
3 Postgatan GÖTEBORG

Kontor i:

MALMÖ
1 Frans Suellsgatan (vid Vallgatan)

HELSINGBORG
14 Norra Strandgatan

STOCKHOLM
28 Skeppsbron

White Star Line agent Carl Eriksson in Gothenburg, Sweden, features an illustration of *Olympic* on his advertising card posted on 7 April 1914. *Britannic* is described as 'under construction'. Note the Statue of Liberty on the right.

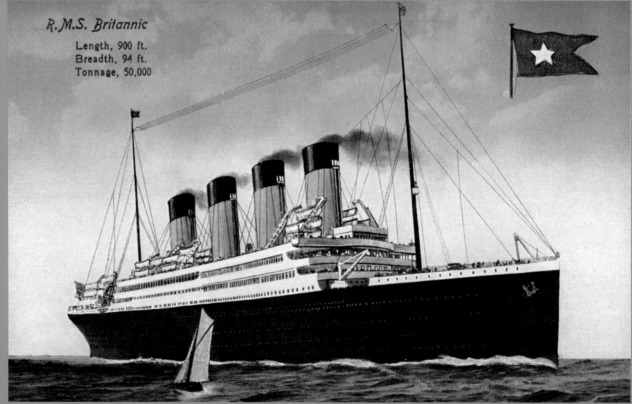

R.M.S. Britannic

Length, 900 ft.
Breadth, 94 ft.
Tonnage, 50,000

White Star's enormous *Britannic*, the third vessel of the Olympic-class trio, as she would have appeared in company colours. Note the innovative lifeboat davits and enclosed forward promenade deck. (Valentines Aerial)

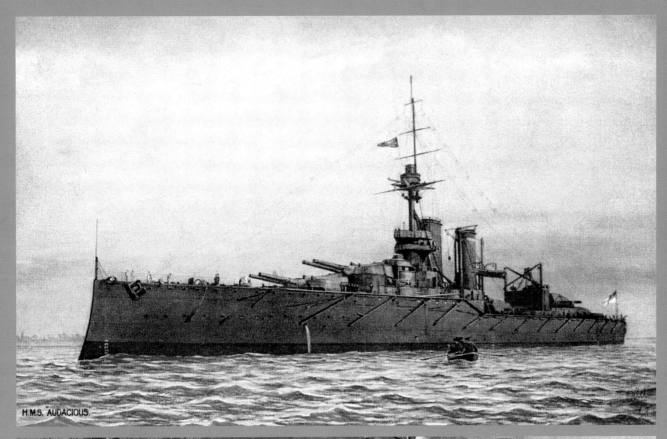

The Royal Navy's new 23,000-ton battleship HMS *Audacious*. Commissioned in 1913, her loss a year later was a major blow to the British Admiralty. (Tuck's Oilette)

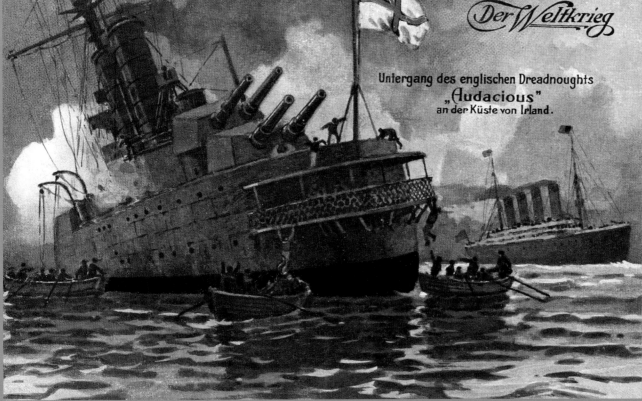

Der Weltkrieg

Untergang des englischen Dreadnoughts „Audacious" an der Küste von Irland.

Posted on 18 July 1915, a couple of months after the loss of *Lusitania*, this *Der Weltkrieg* (World War) series German postcard depicts the loss of HMS *Audacious*, thus thwarting the Admiralty's attempts at a cover-up. *Olympic* is clearly identifiable on the right.

The famous aerial view of *Olympic* as a troopship (viewed from a seaplane whilst in war service). Her camouflage colours would, in fact, have been blue, grey, white and black. Note the guns and crowds of troops at her stern, as well as the enormous number of additional lifeboats. This image featured heavily in White Star's immediate post-war advertising.

WOVEN IN SILK

H.M.S. OLYMPIC.

| Length 883 feet. | Breadth 92½ feet. | Tonnage 46359. | Speed 22½ knots. |

'Woven in Silk' postcards were popular in Britain up to and during the Great War. Under normal circumstances 'OLYMPIC' would be preceded by 'RMS' (Royal Mail Ship). The prefix HMS (His Majesty's Ship) would have covered the period that *Olympic* was serving the Royal Navy after the US entry into the war.

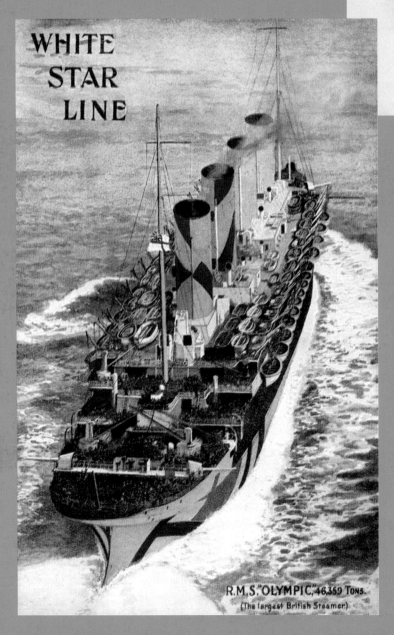

WHITE STAR LINE

R.M.S. "OLYMPIC," 46359 Tons.
(The largest British Steamer)

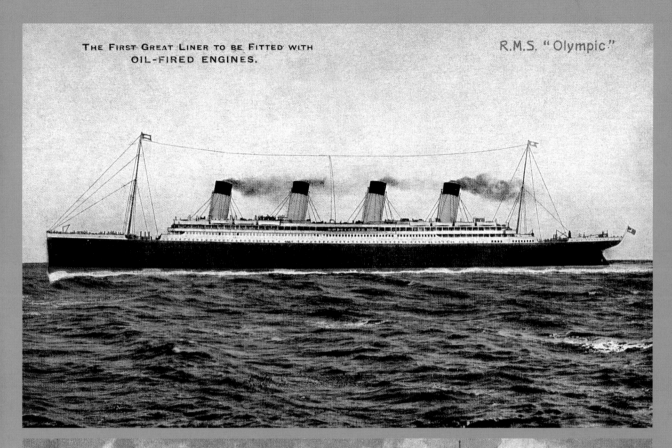

THE FIRST GREAT LINER TO BE FITTED WITH OIL-FIRED ENGINES.

R.M.S. "Olympic."

Olympic was converted to oil power during her post-war refit. This information, however, is stamped on an early card that not only shows smoke emitting from her fourth (dummy) funnel, but also illustrates *Olympic* with a pre-*Titanic* lifeboat layout. (Pratt)

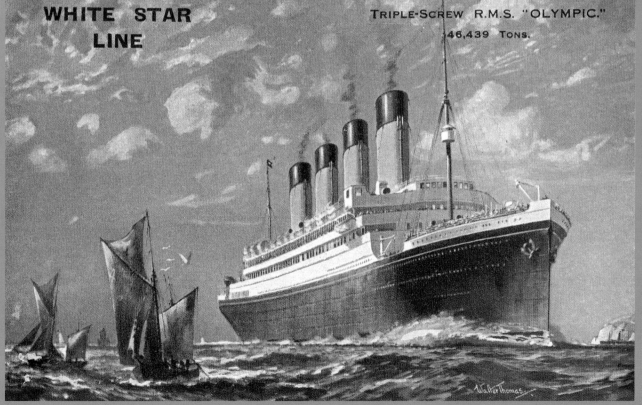

WHITE STAR LINE

TRIPLE-SCREW R.M.S. "OLYMPIC."
46,439 Tons.

A company-issued card depicting *Olympic* from a painting by Walter Thomas. The yellow band round her hull has been lowered indicating that the painting dates after 1921.

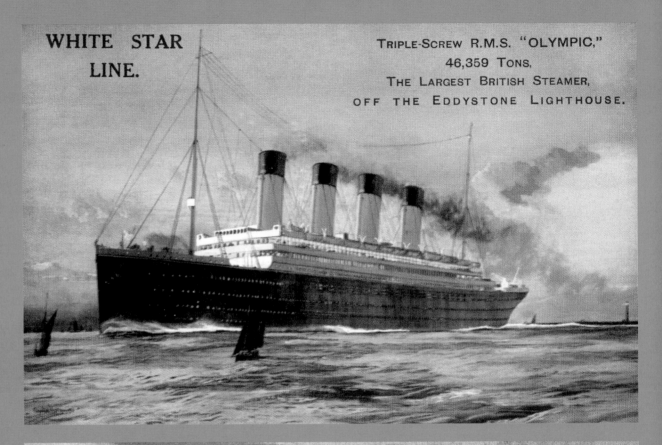

WHITE STAR LINE.

TRIPLE-SCREW R.M.S. "OLYMPIC,"
46,359 TONS,
THE LARGEST BRITISH STEAMER,
OFF THE EDDYSTONE LIGHTHOUSE.

Framed by a golden sunset, with all her cabin lights blazing, this 1920s card illustrates *Olympic* off the Eddystone Lighthouse. Her passengers are probably preparing for their first dinner on board!

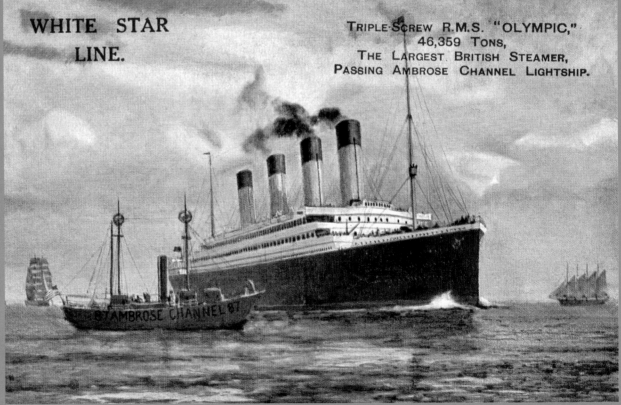

WHITE STAR LINE.

TRIPLE-SCREW R.M.S. "OLYMPIC,"
46,359 TONS,
THE LARGEST BRITISH STEAMER,
PASSING AMBROSE CHANNEL LIGHTSHIP.

This company-issued card indicates that there is still much sail power about as *Olympic* approaches her US destination passing the Ambrose Channel lightship B7.

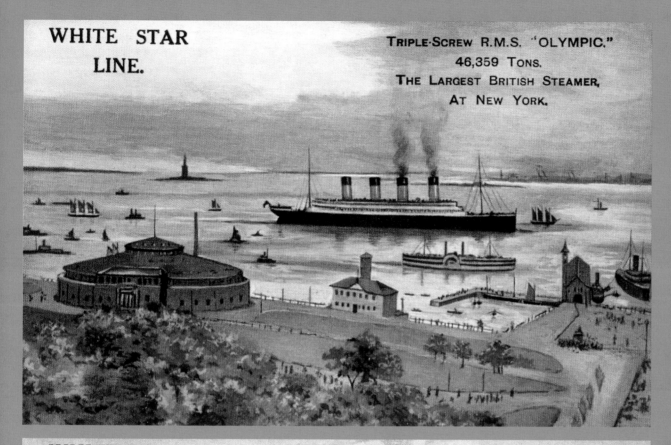

WHITE STAR LINE.

TRIPLE-SCREW R.M.S. "OLYMPIC."
46,359 TONS.
THE LARGEST BRITISH STEAMER,
AT NEW YORK.

Battery Park can be seen in the foreground and the Statue of Liberty is visible on the horizon as *Olympic* sails into New York. Sadly she was the only vessel of the class to arrive here.

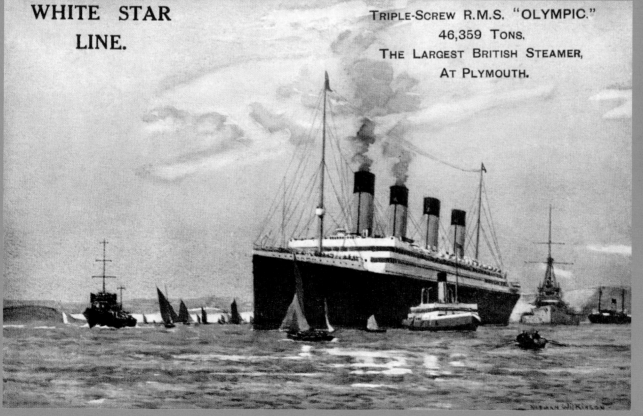

WHITE STAR LINE.

TRIPLE-SCREW R.M.S. "OLYMPIC."
46,359 TONS.
THE LARGEST BRITISH STEAMER,
AT PLYMOUTH.

Plymouth was a popular, convenient first stop on the eastbound crossing, as passengers could take the direct train to London, thus saving a day by avoiding the calls at Cherbourg and Southampton. Note the tender returning to the shore from *Olympic* on this card dated December 1920.

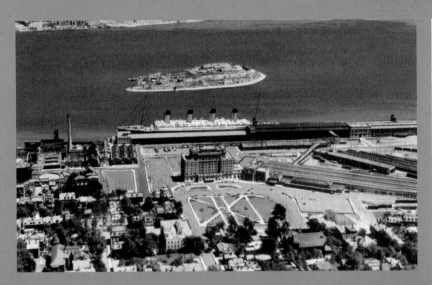

A Canadian National Railways aerial photograph illustrates *Olympic* berthed at Halifax, Nova Scotia. In the early 1930s *Olympic* made several brief cruises to Halifax during her long layover in New York.

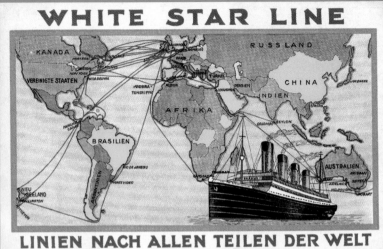

Olympic is featured here on this 1934 German card advertising White Star Line services throughout the world.

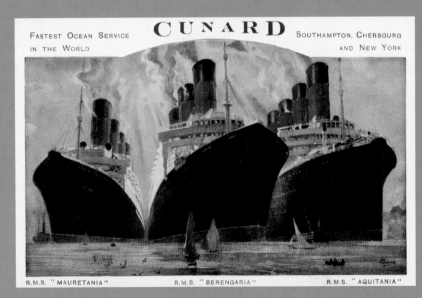

The Cunard three-vessel competition to White Star, featured on a Cunard promotional postcard. *Olympic* can be compared to *Aquitania* on the right.

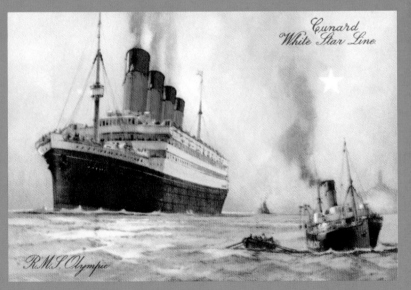

The wording 'Cunard' has been added to this 1920s White Star Line postcard of RMS *Olympic* and, on the reverse, she is still referred to as 'The Largest Triple-Screw Steamer in the World'.

FOR KING AND COUNTRY

The graceful *Aquitania* was Cunard's answer to White Star's Olympic-class liners. Seen here on this card posted in 1949, she survived two world wars. (Photo-Precision)

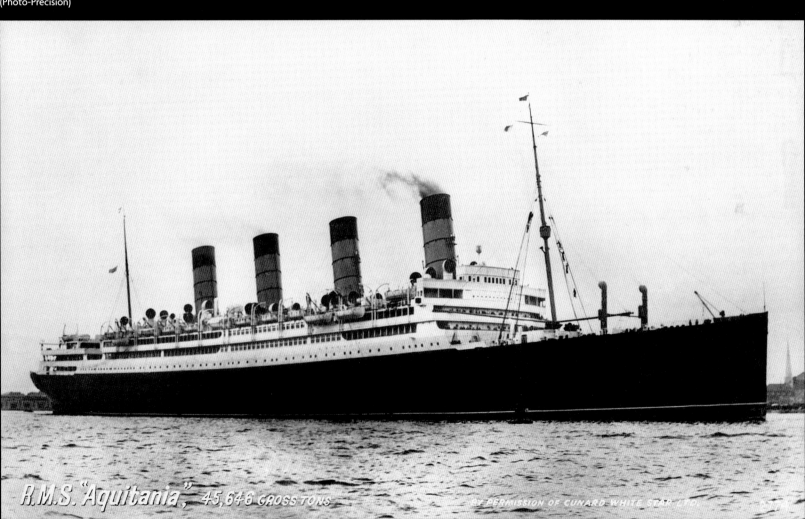

R.M.S. "Aquitania," 45,646 GROSS TONS BY PERMISSION OF CUNARD WHITE STAR LTD.

As the European heads of government, crowned and otherwise, manoeuvred themselves towards the horrors of the Great War, the 'new' *Olympic* maintained a popular and profitable service across the Atlantic. No longer was she the largest liner in the world, for Germany had taken that title for their new *Imperator*. Cunard had launched their 45,647grt *Aquitania* in 1913 to compete with the threat from Germany, and White Star Line, on 30 November 1911, had laid the keel of the third sister, *Britannic*, on the slipway vacated by *Olympic* at Belfast.

Britannic, slightly larger and wider than her sister, was launched at Harland and Wolff on 26 February 1914. It had been possible to enclose her forward first-class promenade ('A') deck as she had been provided with enormous multi-boat davits on her boat deck, occupying less space than *Olympic*'s arrangement. On 14 May Hamburg America Line's 54,282grt *Vaterland* commenced her maiden voyage from Cuxhaven to New York, calling at Southampton and Cherbourg with over 1,600 passengers, followed two weeks later by Cunard's *Aquitania* from Liverpool with 1,055 passengers.

With the storm clouds gathering over Europe, *Olympic* departed Southampton on 29 July 1914, bound for New York, via Cherbourg and Queenstown, carrying 1,140 passengers. War was declared between the United Kingdom and Germany on 4 August, one day prior to *Olympic*'s arrival.

She had reached speeds of up to 25 knots during that crossing and her portholes had been closed to prevent lights being visible at night. Having arrived, the crew set to

Britannic, the third vessel of the Olympic trio, ready for launching at Belfast. She was destined never to serve her owners.

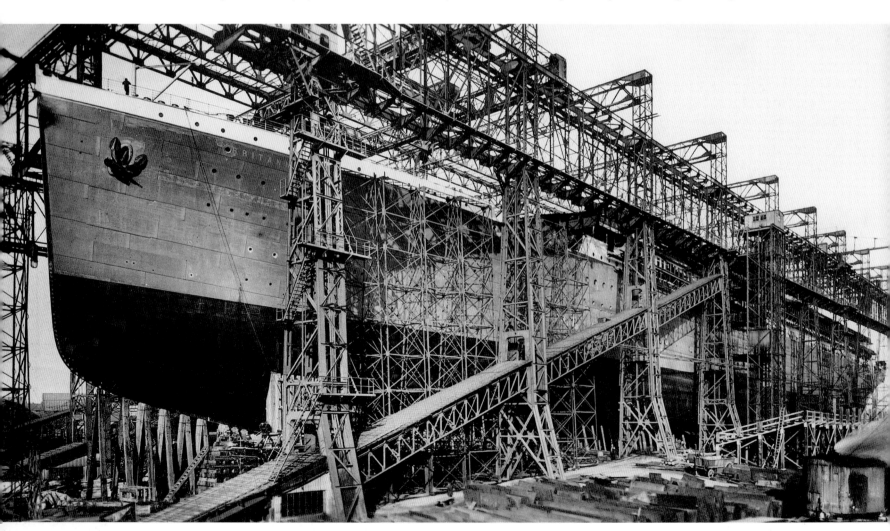

work painting over some of the windows and making her white upper works a dull grey. *Olympic* departed Pier 59 in New York on Sunday 9 August carrying no passengers or cargo. To her starboard as she left, in the New Jersey port of Hoboken, lay the giant German liner *Vaterland* stranded by the outbreak of war and the British naval blockade of her country. The crew of *Olympic* taunted their opposite numbers on *Vaterland* as they passed. Reaching speeds of up to 24 knots, *Olympic* arrived in Liverpool on 15 August.

Another German vessel, the crack express liner *Kronprinzessin Cecilie*, attempted to evade capture. Her captain, Pollack, disguised his ship to resemble *Olympic* by painting her funnel tops black, and safely reached internment at Bar Harbour, Maine.

White Star Line continued to provide their usual weekly service, but from Liverpool, using *Olympic*, *Adriatic*, *Baltic* and Red Star's *Lapland*, which had been transferred to White Star Line management after the loss of her home port of Antwerp following the fall of Belgium. Americans, escaping the war in Europe, and British, returning to the UK to join up, contributed to the large number of passengers filling the vessels. *Olympic*, with Liverpool

finding it difficult to handle a ship of her size, was moved to Greenock.

The 21 October 1914 voyage, from New York to Greenock, was interrupted by the mining of the British battleship HMS *Audacious*. During the early days of the war the German liner *Berlin*, later to become White Star Line's third *Arabic*, had laid mines off the north coast of Ireland. The 24,000grt new battleship had struck one of these mines, off Tory Island, at 8.50 a.m. on Tuesday 27 October. As *Audacious* started to flood, the nearby *Olympic* was ordered to help evacuate her crew, 250 of whom were transferred to *Olympic* and a further 450 to other warships using some of *Olympic*'s lifeboats. Several attempts were made to tow the stricken battleship. The heavy sea not only thwarted these efforts but increased the amount of water being taken on by *Audacious*. As the warship began to settle deeper, *Olympic* took on board the remainder of the crew and departed for Lough Swilly, abandoning her lifeboats. The recovery of these had been rendered impossible by the rough sea. *Audacious*, after an internal explosion, capsized and sank stern first at 9 p.m.

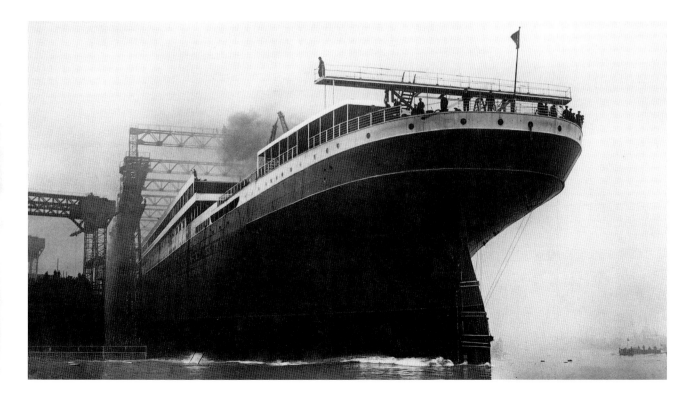

The giant *Britannic* takes to the water and an uncertain future as Europe prepares for war.

The Admiralty was desperate to cover up the loss of *Audacious*, even to the extent of modifying a cargo vessel to resemble the battleship. Nearly a week was to pass before *Olympic*'s passengers were disembarked at Belfast, their mail in the meantime having been censored by *Olympic*'s purser and a naval officer. Despite these attempts at cover-up, rumours began to circulate in the British press and the Admiralty was forced to announce that 'None of the crew of Audacious had been lost'. In response to enquiries about individual members of the crew, the reply was: 'According to the latest information ——— is well and serving with the fleet.'

For the next ten months *Olympic*, crewed only by a maintenance team from Harland and Wolff, remained at Belfast together with her sister *Britannic*, which was nearing completion, pending a decision about their future. It had been realised that the unsuitability of large vessels for patrol duties rendered them vulnerable to attack and subsequently, by the spring of 1915, both *Olympic* and *Britannic*, with Cunard's *Aquitania* and *Mauretania*, had been laid up.

Vaterland, the second vessel of Germany's giant trio, was trapped in New York at the outbreak of the Great War.

Länge	.	.	276,00 m
Breite	.	.	30,50 m
Tiefe	.	.	19,25 m
Brutto-Tonnengehalt			56,000
Passagiere	.	.	4,050
Besatzung	.	.	1,200

Hamburg-Amerika-Linie P.-D. „Vaterland"
Das grösste Schiff der Welt

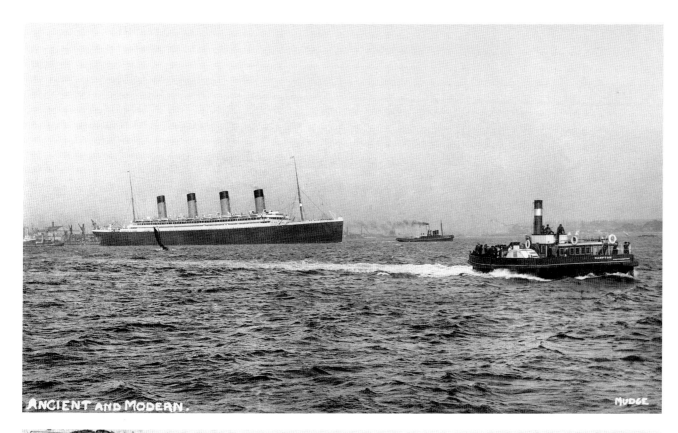

ANCIENT AND MODERN.

MUDGE

Olympic departs Southampton in pre-war 1914. The 1894 Hythe paddle ferry *Hampton* is on the right. (Mudge)

Transatlantiques « *Olympic* » et « *Kromprinzessin Cecilie* » à l'Escale de Cherbourg

Collection L. G. B.

Peacetime at Cherbourg. Soon, *Olympic* and *Kronprinzessin Cecilie* will be on opposing sides as Europe goes to war.

Kronprinzessin Cecilie disguised as *Olympic* in order to evade capture by British warships. She is seen here, interned at Bar Harbour, Maine, from where this card was posted in August 1914. Upon the US entry into the Great War she became the troopship USS *Mount Vernon* and was scrapped in 1940.

During the afternoon of 7 May 1915 the Cunard liner *Lusitania*, as she was approaching Queenstown, was torpedoed off the Old Head of Kinsale by the German submarine *U20*. Despite the two explosions, the commander of the submarine stated that only one torpedo was fired. It is thought that the second, and more serious, explosion was either coal dust in empty bunkers being ignited or the cold seawater reaching the heated boilers. The torpedo struck *Lusitania*'s hull between the first and second funnels on the starboard side. She heeled over to star-

board and sank within eighteen minutes, taking with her approximately 1,200 lives. Amongst the dead were 128 US citizens and this loss of life would be a major contributor to the entry of the United States into the war in 1917.

Four days later, as military activity began to build up at Gallipoli and in the Dardanelles, *Mauretania* and *Aquitania* were taken over for trooping duties. Within five months they would be converted to hospital ships.

On 2 September 1915 White Star Line was advised that *Olympic* would be required for trooping duties, the

Mailsteamer „Lapland".
Length 620 feet. Beam 70 feet. Tonnage 18694.

Red Star Line's *Lapland* was transferred to White Star after the fall of her home port of Antwerp. She joined *Olympic* on the Liverpool to New York wartime service.

Olympic" and L.S.P. Co's "Duchess of Fife."

Olympic's UK port was switched to Greenock as Liverpool found it increasingly difficult to accommodate the giant liner. She is seen here in the Clyde attended by the paddle steamer *Duchess of Fife*.

101/2/18 RMS Arabic

The German liner *Berlin*, to become White Star's third *Arabic* after the Great War, laid the minefield in the Irish Sea that resulted in the loss of HMS *Audacious*.

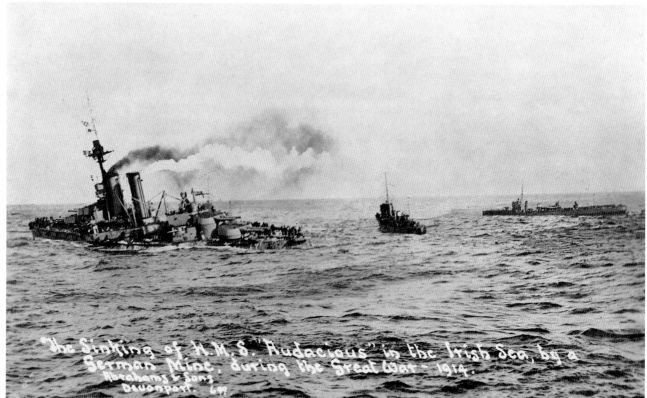

The Sinking of H.M.S. "Audacious" in the Irish Sea, by a German Mine, during the Great War - 1914.
Abrahams & Sons
Devonport. 647

HMS *Audacious*, her stern already awash, wallows in the Irish Sea after striking a German mine. It is believed that the photograph was taken from the deck of *Olympic*. (Abrahams)

government paying, as with Cunard, approximately £23,000 per month. The Thompson dock at Belfast was occupied and therefore conversion work was carried out at Liverpool's Gladstone dock where she could also be supplied with coal as the work continued.

During *Olympic*'s lay-up at Belfast, Captain Haddock had been put in charge of the navy's 'Ghost Fleet' of merchant vessels disguised to resemble warships. The navy considered that he was too valuable to lose at such a time and therefore Captain Bertram Fox Hayes was appointed to *Olympic*. He was to command her longer than any of her other captains.

Completed by the end of September 1915, conversion to a troop-carrying capacity of over 6,000 involved the removal of many of *Olympic*'s passenger fittings. Those that could not be moved, such as the grand staircase, were boarded over. Troop accommodation was primarily contained on 'C', 'D' and 'E' decks, the second-class library became a 100-bed hospital and the first-class dining and reception rooms were supplied with hammocks and mess facilities for over 3,300 troops.

Olympic, as transport T2810, departed Liverpool for Mudros Harbour on the island of Lemnos on 25 September, calling at Gibraltar and the Italian port of Spezia for coal. A naval crew of four manned the 12-pounder gun forward and 4.7in gun aft. The watertight doors remained closed and the ship was blacked out with navigation lights used only when necessary throughout the voyage. On 1 October, in the Mediterranean, Hayes rescued thirty-four men in a lifeboat from the French *Provincia*, for which he was severely criticised by the Admiralty as not only endangering his ship but risking the lives of nearly 6,000 men on board. In his memoir *Hull Down*, published after the war, Hayes states: 'Slowed Olympic down and proceeded again at full speed.' Despite the Admiralty's condemnation, for his actions Hayes was awarded France's Gold Medal of Honour.

Olympic made four round-trip voyages to Mudros, covering nearly 30,000 miles and carrying over 25,000 men. At the end of her second voyage she was reunited at Liverpool with *Britannic*, now a hospital ship painted white with buff funnels and large red crosses on her side, breaking a wide, green, horizontal stripe. They were destined to meet again, for the last time, at Southampton in

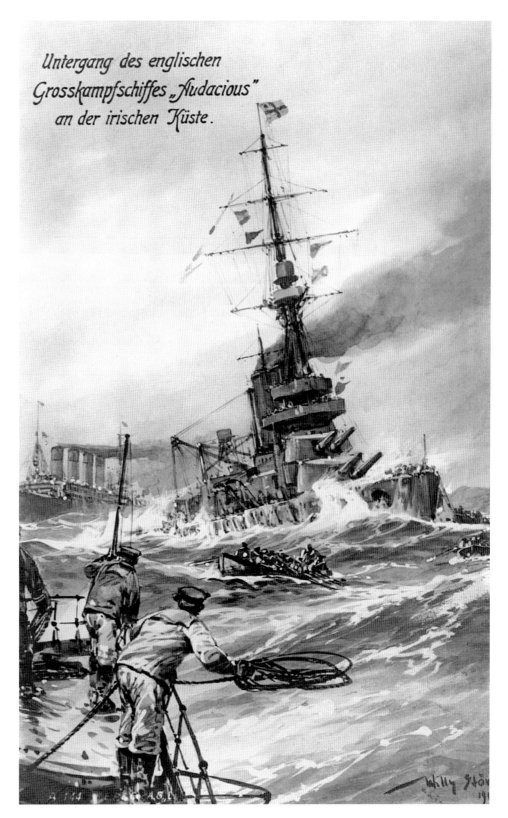

Despite the Admiralty's attempts to cover up the loss of *Audacious*, the Germans were quick to publish this artist's impression of the event. *Olympic* is clearly identified on the left.

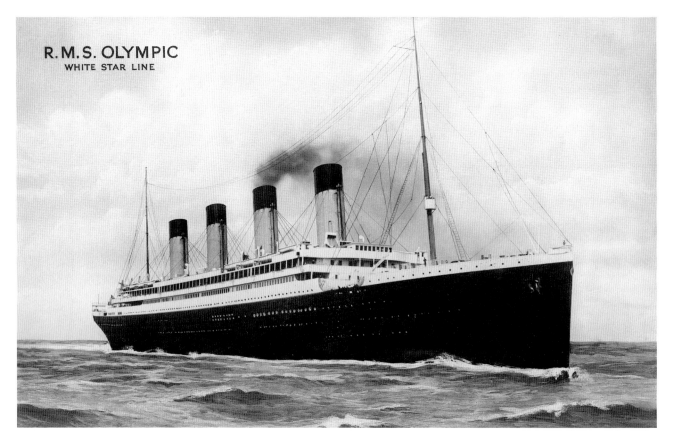

A pre-*Titanic* view of *Olympic* posted at sea. The message reads: 'Olympic Oct 18: 1914. Had a lovely passage not been sick at all & having real Canadian weather now. This is lovely boat inside. We are sitting up on deck to write & it is lovely & warm. We are expecting to land tomorrow night. Marked with an "X" where we are sitting.' The 'X' is visible by the last starboard lifeboat, which would have been the second-class promenade area.

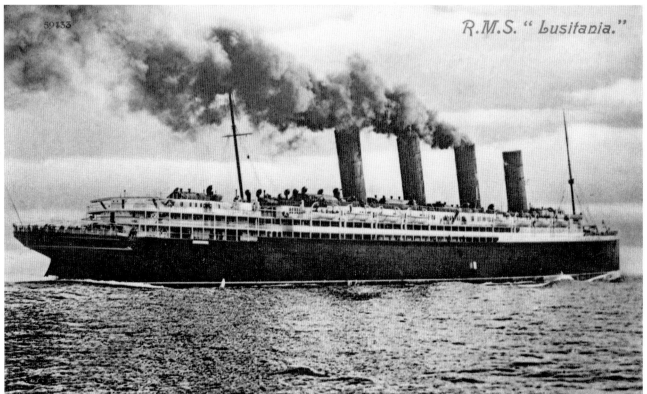

The loss of Cunard's *Lusitania* to a U-boat torpedo on 7 May 1915, with appalling loss of life, was a major contributor to America's entry into the First World War two years later.

February 1916. After the British evacuation from Gallipoli in December 1915, *Olympic* was no longer required once she had finally returned to Liverpool in March 1916 and she awaited her next call of duty.

She did not have long to wait. Chartered to the Canadian government to transport their troops to Europe, *Olympic* departed Liverpool on 22 March 1916 and arrived at Halifax, Nova Scotia, six days later. Initially the Canadians had wanted *Olympic* to sail in convoy, which would have restricted her speed to 12 knots, but Hayes pointed out that speed was her best defence and she was permitted to sail alone and unescorted. Ten voyages had been made between Liverpool and Pier 2 at Halifax by the end of 1916.

Britannic left Southampton on 12 November 1916, took on extra coal at Naples and departed for Mudros on the 17th. At 8.12 a.m. on 21 November she ran into a minefield in the Zea Channel 4 miles west of the island of Kea. The explosion occurred on the starboard side below the bridge and the forward compartments began to flood. The explosion had rendered the watertight doors inoperable and many of the ship's portholes were open in order to 'air' the vessel before collecting the wounded servicemen.

Attempts were made to beach *Britannic* as preparations began to evacuate the 1,125 persons aboard. Mercifully she was carrying no wounded patients at the time and those on board consisted of medical staff and crew.

Throughout 1916 *Olympic* transported Canadian troops to Europe. This card was posted at Ottawa on 5 June 1916 with the message: 'Dear Friend. Just to let you know we are about to sail. Came on board Wed. morning. Will send you a letter when I arrive in Eng. Bye.'

CANADIAN EXPEDITIONARY FORCE

CANADA TO ENGLAND, JUNE, 1916

For Peace, Justice and Freedom. *God Save the King.*

Transport T2810, *Olympic*, arrives back at Halifax, Nova Scotia, to carry thousands more Canadian troops to Europe. The forward 12-pounder gun is just visible in this photograph.

Olympic prepares to depart Halifax for the UK. Note the 4.7in gun on the stern and the screens over the large windows at the rear of the centre superstructure.

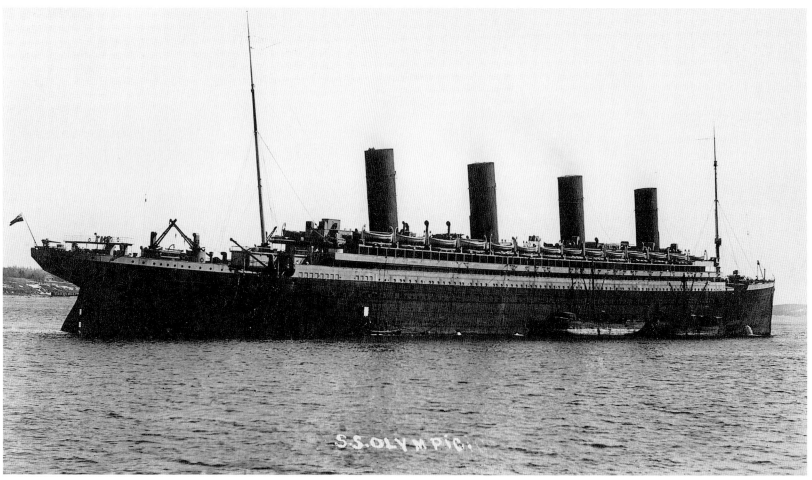

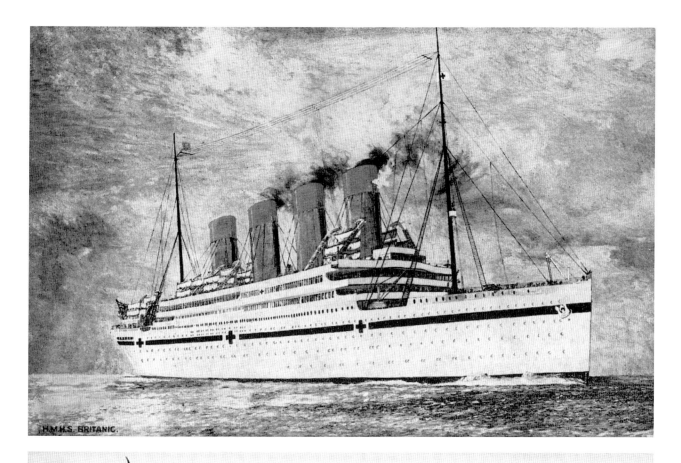

H.M.H.S. BRITANIC.

HMHS *Britannic* would never see peacetime service for her owners. As a hospital ship with white hull, buff funnels, a green band round her hull and six large red crosses, she struck a mine off the Greek mainland on 21 November 1916.

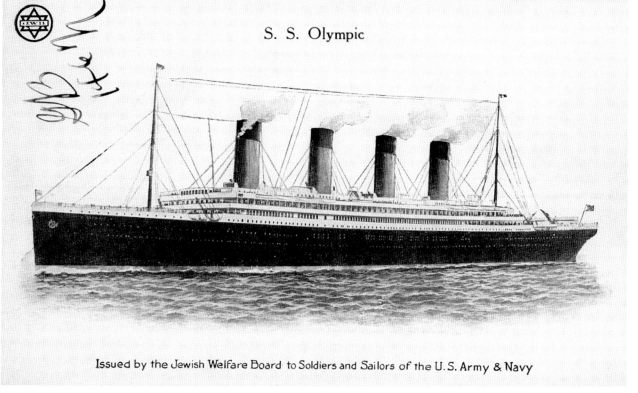

S. S. Olympic

Issued by the Jewish Welfare Board to Soldiers and Sailors of the U. S. Army & Navy

Olympic was switched from Halifax to New York upon America's entry into the war on 6 April 1917. This card would have been issued to the soldiers and sailors being transported to Europe. The following note is on the reverse: 'Soldiers mail. No postage necessary if mailed on boat or dock.'

Two lifeboats were smashed to pieces by a slowly turning propeller that emerged from the sea as the bow began to settle. An hour after the explosion *Britannic* lost her stability, listed to starboard and sank in 600ft of water. Escorting warships rescued the survivors but thirty-four persons had lost their lives in the disaster.

Britannic would be the largest vessel in the British merchant marine to be sunk in war. With the loss of her second sister, *Olympic* was now alone.

In need of an urgent overhaul, *Olympic* returned to Belfast on 12 January 1917. Hayes transferred temporarily to command *Celtic* and rejoined *Olympic* in Glasgow after her refit on 3 April. Events now moved swiftly to affect *Olympic*'s future. With the British naval blockade of their country biting deep, Germany introduced 'unrestricted

submarine warfare' in the spring of 1917. The United States declared war on Germany on 6 April.

Now flying the Royal Navy's White Ensign, His Majesty's Transport No. 527 resumed her war duties sporting dazzle-paint camouflage, in a mixture of black, white, grey and blue, designed by the artist Norman Wilkinson. Coincidentally, he had painted the two pictures that had hung in the smoking rooms of *Olympic* and *Titanic*. The camouflage design appears to have been amended on several occasions. She was re-armed with six 6in guns manned by forty Royal Naval ratings.

Olympic arrived back at Pier 59 in New York on Christmas Day 1917 to embark her first contingent of US troops. She departed Southampton on 22 April for her twenty-second trooping voyage and, having left New

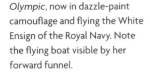

Olympic, now in dazzle-paint camouflage and flying the White Ensign of the Royal Navy. Note the flying boat visible by her forward funnel.

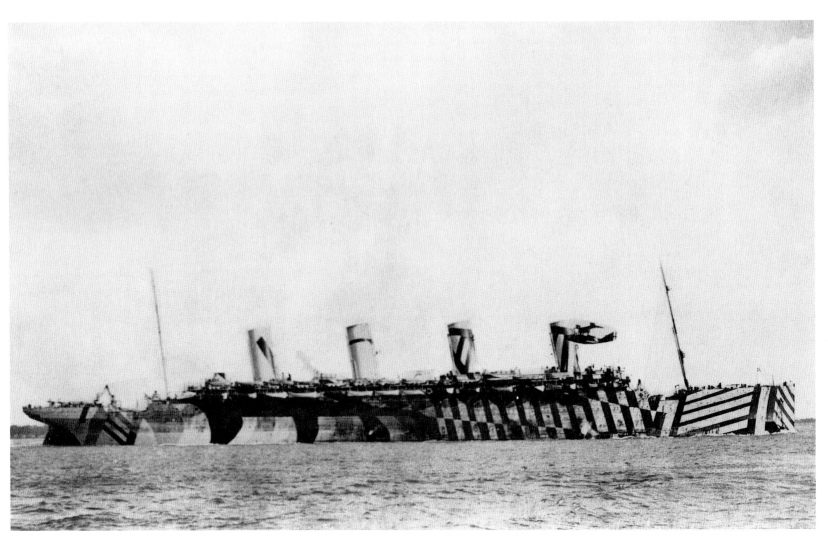

York on 6 May 1918, she reached the English Channel six days later. Between Plymouth and Brest as dawn began to break *Olympic* saw, silhouetted against the silver streak of daylight, the surfaced German submarine *U103*. Coming out of the dark *Olympic* was at first not noticed by the submarine and Hayes decided to ram the enemy vessel.

At 3.55 a.m. on 12 May 1918 *Olympic* became the first merchant vessel to sink an enemy submarine. Her full force struck the 800-ton submarine now trying desperately to avoid the oncoming liner. Nine members of the crew perished but escorting American destroyers rescued thirty-one survivors from the stricken submarine

Artist Norman Wilkinson created *Olympic*'s dazzle-paint camouflage, believed to have been a combination of black, white, grey and blue. Her wartime troopship identification 'T2810' is still visible below the bridge.

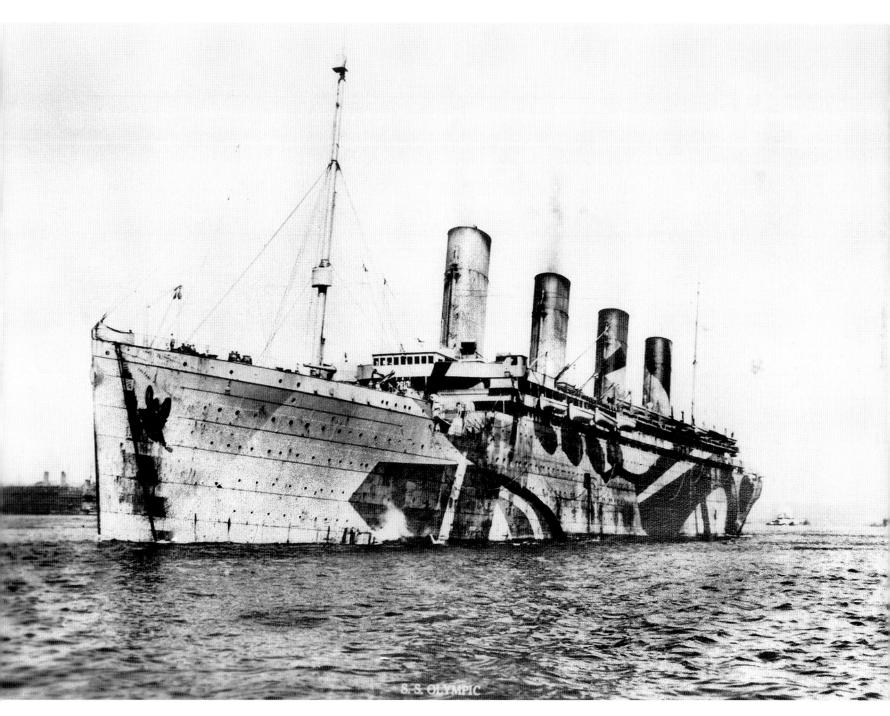

S. S. OLYMPIC

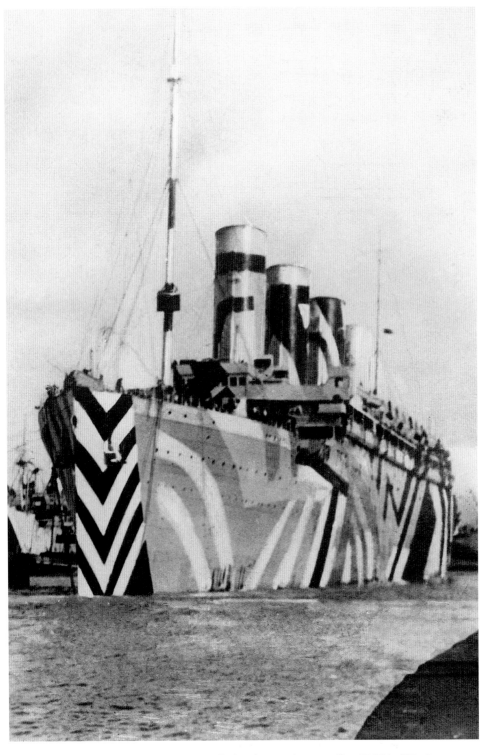

Sporting a further change to her camouflage, HMT No. 527 waits at Southampton prior to her next crossing. (Real Photo Series – Pratt)

as *Olympic* continued on to Southampton. After initial inspection it was discovered that, although her stem was bent some 8ft to port, her hull's integrity remained undamaged. Hayes was awarded the DSO, lookout Bennett the DCM and the crew shared between them £1,000 presented by the Admiralty. Germany offered a reward of $100,000 for the sinking of *Olympic* and the life of Hayes.

Olympic arrived in New York on 10 November 1918 and the next day Germany, facing starvation as a result of the successful naval blockade, surrendered. The vessel was not to be released for peacetime duties for some time, however. Thousands of Canadian and US troops had to be repatriated and *Olympic*, now flying the Red Ensign having been decommissioned from the Royal Navy in February 1919, began the enormous task. She arrived back in Liverpool on 21 July 1919 and, three weeks later, sailed to Harland and Wolff for a major post-war refit. During the Great War *Olympic* had made thirty-four voyages as a troopship, transporting over 200,000 troops and travelling over 180,000 miles. She became the war's most successful troopship and earned the title of 'Old Reliable'.

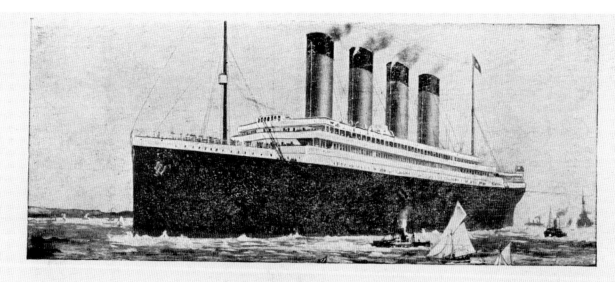

H. M. S. "OLYMPIC" LEAVING SOUTHAMPTON

"THE SHIP THAT BROUGHT ME HOME"

Left SOUTHAMPTON, January 11th, Arrived HALIFAX, January 17th, 1919

1914 - Canadian Expeditionary Force - 1918

MONS	ST. ELOI	NEUVE CHAPPELE	YPRES 2	FESTUBERT	GIVENCHY	LA BASSE	LOOS
PLUGSTREET	ST. JULIEN	YPRES 3	THE SOMME	COURCELETTE	VIMY RIDGE	HILL 70	
PASCHENDALE	AMIENS	ARRAS	CAMBRIA	VALENCIENNES	OCCUPATION OF MONS, NOV. 11		

After the cessation of hostilities in November 1918, the massive task of repatriating thousands of Canadian and American troops lay ahead. *Olympic* would not be released from government service until July 1919.

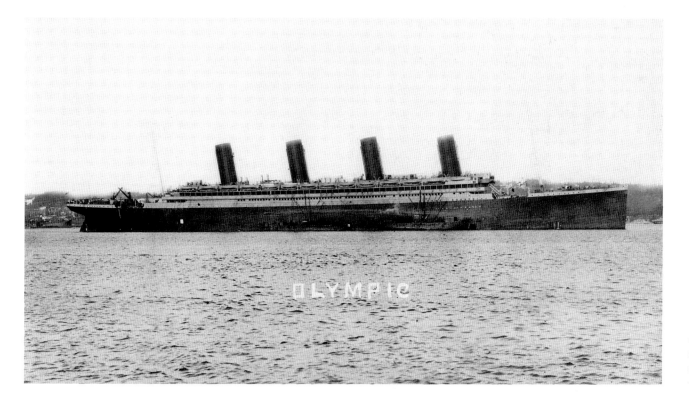

Olympic back at Halifax, Nova Scotia, and once again under the Red Ensign, returning Canadian troops in 1919.

'Old Reliable' at Halifax in 1919
with hundreds of returning
Canadian troops swarming over
her fo'c'sle. Despite peace having
been declared, her name is still
not visible on the bow.

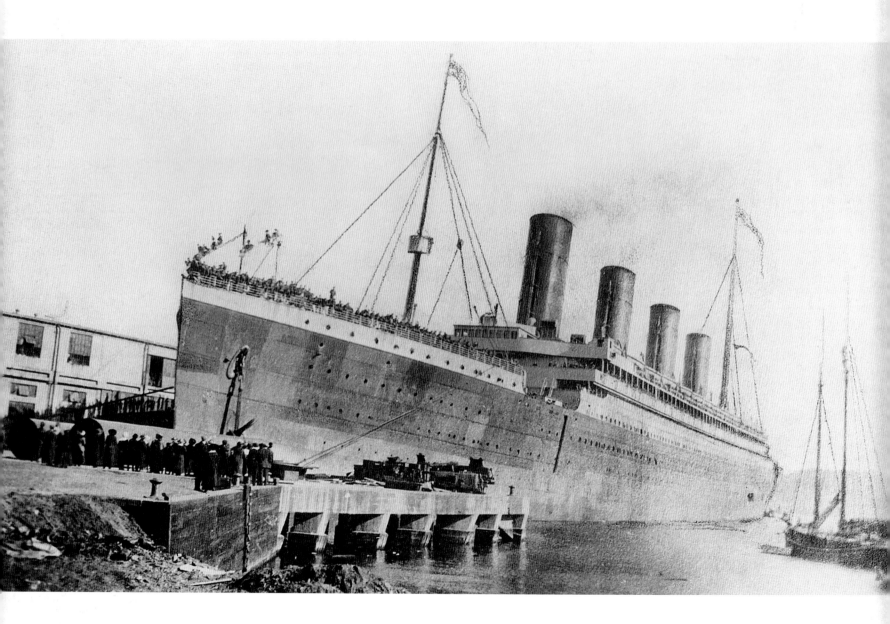

ROARING TWENTIES

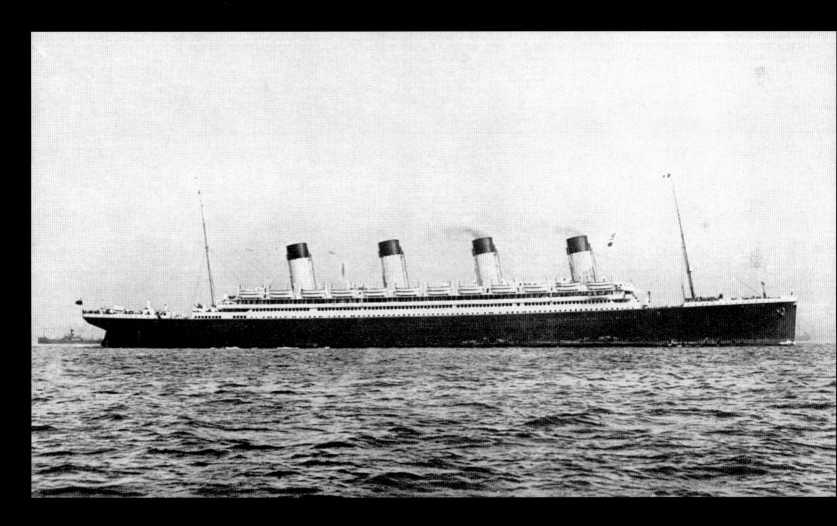

The 'new' oil-fired *Olympic* after her 1919/20 refit. She has yet to be joined by her ex-German running mates.

lympic arrived in Belfast on 16 August 1919. During her post-war refit that winter she was virtually rebuilt internally. The strains of nearly five years' service to her country had taken an enormous toll, and major reconstruction and refitting was now required.

Most importantly, she was converted to oil firing. Despite coal being far less expensive, the benefits of oil outweighed the disadvantages. No longer would days be spent refuelling, with the problem of coal dust everywhere, and the number of men required in her engine room would be reduced from nearly 300 to 60. In addition, passengers would not be subjected to burning embers being blown back on to the deck, nor would there be the smell of burnt coal. Oil fuel was carried within the spaces of the double skin, as well as in the original bunkers, which had been converted.

Murray's 'nested' lifeboats were supplied, which involved twenty-four sets of 'Welin' davits housing a 28ft boat inside a 30ft boat, the first set on each side having a 26ft cutter in addition, making a 'nest' of three. These fifty lifeboats had a capacity of 3,428. Although a reduction of the 1913 capacity, this was a vast improvement on that prior to the loss of *Titanic*!

The first-class reading and writing room was now referred to as the 'drawing room', and linoleum and rugs replaced the carpet in the first-class cabins. The 'new'

Olympic's post-war lifeboat arrangement is clearly visible in this close-up at Cherbourg. Note the port-side cutter swung out whilst in harbour and the open promenade deck. (Desaix)

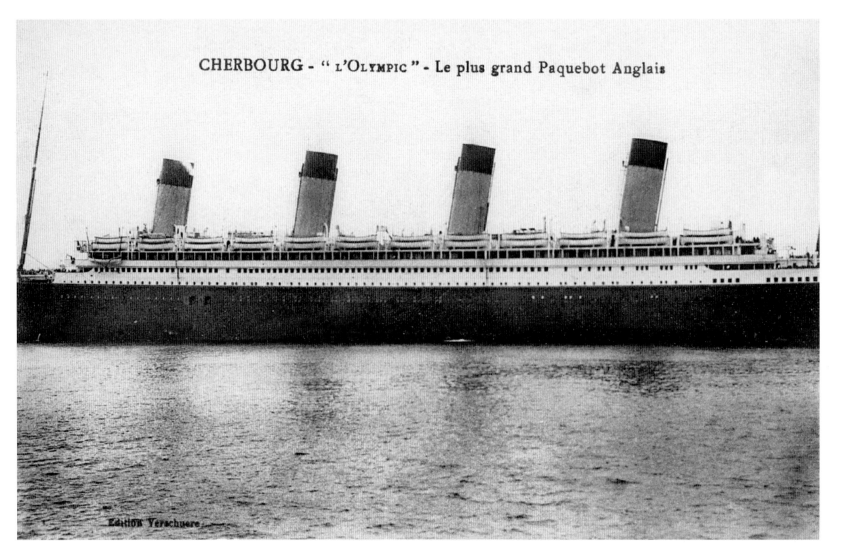

CHERBOURG - " L'OLYMPIC " - Le plus grand Paquebot Anglais

Edition Verschuere

Olympic at Southampton prior to her next departure. Note the covers over eight nests of lifeboats.

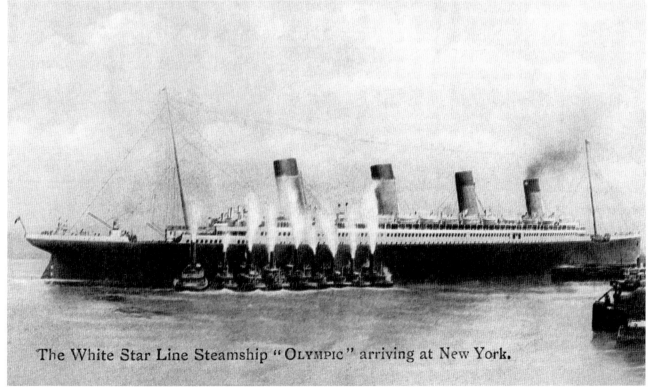

The White Star Line Steamship "OLYMPIC" arriving at New York.

Nine tugs, dwarfed by the giant Olympic, assist the liner as she arrives at New York.

The German *Imperator*, which had stolen the title 'World's Largest Steamer' from *Olympic* in 1913, was ceded to Britain after the Great War to become Cunard's *Berengaria*. (C.R. Hoffmann)

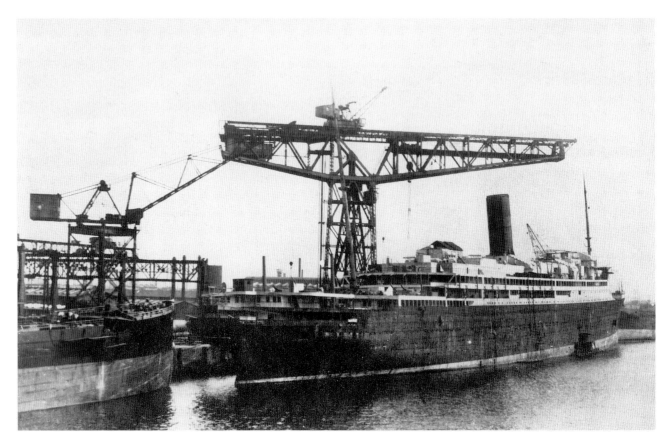

Bismarck, the third and largest of the German trio, lay incomplete at Hamburg throughout the Great War.

R. M. S. Homeric.

The ex-German *Columbus* was handed over to the Allies to become White Star's *Homeric*. Despite her steadiness at sea, she did not have sufficient power to maintain a successful three-ship service.

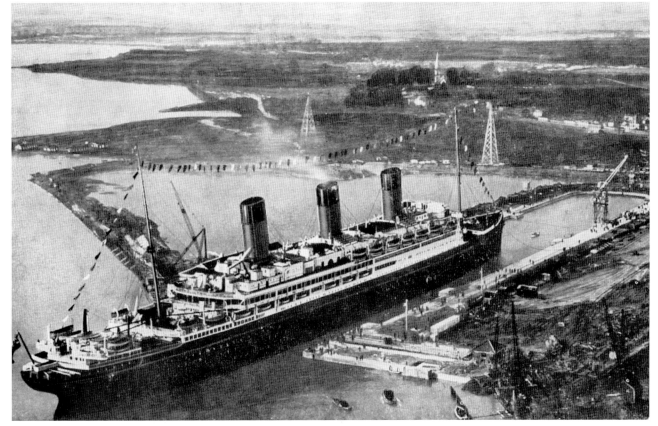

White Star's giant *Majestic*, ex-*Bismarck*, entering the King George V dock at Southampton. She held the title 'World's Largest Liner' for over ten years.

Olympic departed Belfast on 17 June 1920 for trials; her first peacetime departure from Southampton was on 26 June, commanded by Captain Hayes and she was nearly full to capacity. During her absence, White Star Line's express New York service had been maintained by *Adriatic* and *Lapland*, the latter returning to Belgium to resume Red Star Line's Antwerp–New York operation.

After the end of the Great War, Germany lost the bulk of her merchant marine to the victorious Allies. On 17 November 1919 the Shipping Controller supplied a list of vessels allocated to Britain to the Cunard and White Star Lines. Cunard, having lost twenty-two vessels in the conflict, was given priority and they purchased the *Imperator*, renaming her *Berengaria*.

In September that year the American-owned White Star Line extended, for another twenty years, the agreement whereby all their vessels would be British-registered, carry British officers and be available to the British government at time of war. This agreement thus entitled White Star Line to ships from the surrendered German fleet. The first of these would be North German Lloyd's 35,000grt *Columbus*, nearing completion in Germany and due in 1920. Secondly, Hamburg America Line's giant 56,551grt *Bismarck* would be available nine months later. In addition, White Star Line was allocated North German Lloyd's *Berlin*, the same vessel that had laid the minefield that sank HMS *Audacious* at the beginning of the war.

Columbus, renamed *Homeric*, joined White Star Line on 15 February 1922 and *Bismarck* was to become White Star Line's *Majestic*, the world's largest liner for many years. *Majestic* did not make her maiden voyage until 10 May 1922 as the decision to convert her from coal to oil power, alongside German reluctance to complete and part with their vessel, created a considerable delay. The two vessels joined *Olympic* in providing the company's three-ship Southampton–Cherbourg–New York service in the 1920s. *Berlin* would be renamed *Arabic* and employed on White Star Line's Mediterranean service. The unfortunate *Vaterland*, stranded in New York at the

Germany's *Vaterland*, having been seized in New York upon America's entry into the war in 1917, becomes the United States Lines' *Leviathan*. (C.R. Hoffmann)

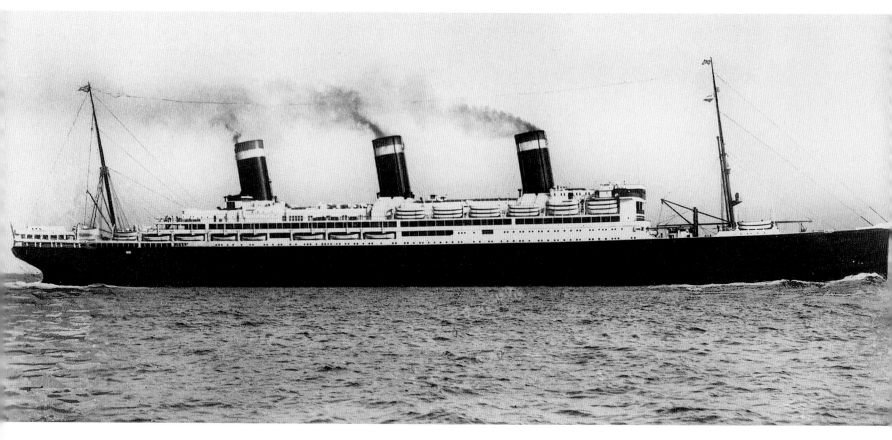

WHITE STAR LINE.

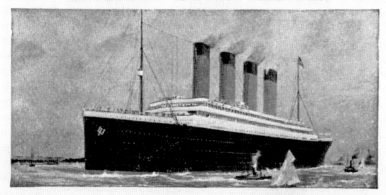

THIRD CLASS.

R.M.S. "OLYMPIC." MAY 20, 1913

BREAKFAST.

HOMINY & MILK
CREAMED SALT COD JACKET POTATOES
VEGETABLE STEW
FRESH BREAD & BUTTER
MARMALADE SWEDISH BREAD
TEA COFFEE

DINNER.

PEA SOUP
CORNED BRISKET OF BEEF AND CABBAGE
BAKED POTATOES
FRESH BREAD CABIN BISCUITS
SAGO PUDDING

TEA.

FRESH FRIED FISH
FRESH BREAD & BUTTER
SWEDISH BREAD MARMALADE
STEWED GREENGAGES & RICE
TEA

SUPPER

BISCUITS & CHEESE
... respecting the Food supplied, want of attention
...uld be at once reported to the Purser or Chief
... urposes of identification, each Steward wears a
... the arm.

WHITE STAR LINE.

THIRD CLASS

R.M.S. "OLYMPIC." - SEPTEMBER 6th, 1922.

BREAKFAST.

Rolled Oats with Milk
Finnon Haddie
Broiled Sausages, Mashed Potatoes
Fresh Bread Marmalade Tea Coffee

DINNER.

Vegetable Soup
Boiled Codfish, Egg Sauce
Roast Mutton, Onion Sauce
Carrots and Turnips Boiled and Roast Potatoes
Bread and Butter Pudding

TEA.

Rabbit and Ham Pie
Cold Roast Lamb and Morta Della Sausage
Mixed Pickles Cheese Potato Salad
Compote of Figs Currant Buns
Preserves Fresh Bread Tea

SUPPER—Biscuits Cheese Gruel

Any complaint respecting the Food supplied, want of attention, or incivility, should be at once reported to the Purser or Chief Steward.

Olympic's third-class all-day menu for 1913 carries an advertisement on the reverse for 'Olympic. The largest Steamer in the World', *Titanic* having been lost and *Britannic* not yet complete.

Post-war dietary improvements are reflected in a similar menu for 1922. On the reverse *Olympic* is joined by *Majestic* (completing) and *Homeric*.

commencement of the war, was taken over by the United States as a troopship upon their entry into the war and renamed *Leviathan*. She would later be allocated to the United States Lines. *Adriatic* rejoined her 'Big Four' sisters at Liverpool upon the arrival of *Majestic* in the Southampton service in May 1922.

Prior to the Great War, immigrants to America and Canada numbered in excess of 1 million annually. However, 1921 was to produce a major change to United States immigration policy. In May that year the Dillingham Immigration Restriction Act (to become known as the '3% Act') set a limit to the number of emigrants seeking admission to 'three per cent of the foreign born population as at the 1903 census'. This drastic reduction, effective from July, represented an annual

limit of 360,000. Five years later this limit was further reduced to 160,000: White Star Line and Cunard were going to have to rethink the space allocated to third class, just as they were to take over two of the largest vessels in the world.

Olympic had lost her title as the world's largest ship but was still referred to, in company literature, as 'the largest British-built ship'. Towards the end of 1921 she made her fastest return passage across the Atlantic and it was during this year that the yellow band, between the black hull and the white superstructure, was lowered by one line of plates to leave a black space above. Subsequent to her post-war refit maiden voyage she settled down to operate the three-ship service, with *Homeric* and *Majestic*, competing with Cunard's *Berengaria*, *Aquitania*

The outbound *Olympic* makes a fine sight as she passes the quiet Royal Yacht Squadron at Cowes, Isle of Wight. (Sweetman)

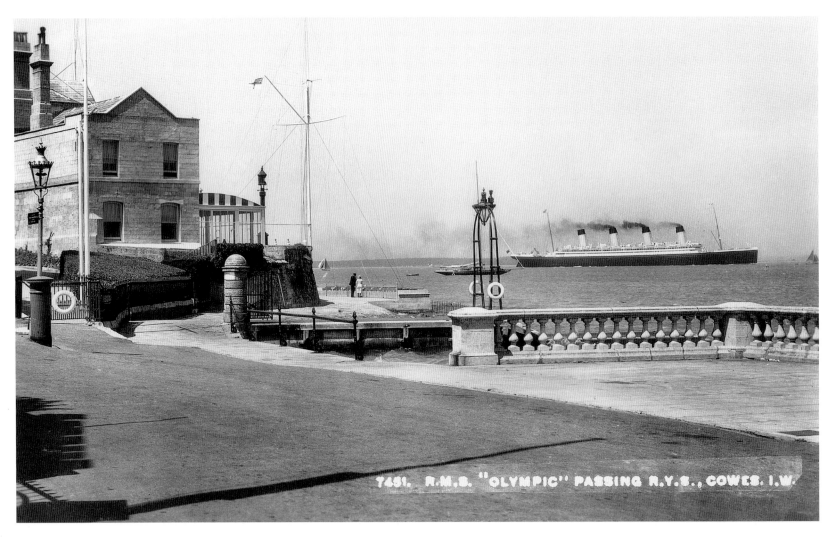

7451. R.M.S. "OLYMPIC" PASSING R.Y.S., COWES. I.W.

and *Mauretania*. Cunard had moved their express New York service to Southampton in 1922.

Captain Hayes had been in command of *Olympic* for nearly seven years but, after her arrival in Southampton on 7 January 1922, he transferred to *Majestic* and was given the title 'Commodore of the White Star Fleet'.

Passenger loads in 1923 indicated that *Olympic* was the fourth most popular vessel in first class across the Atlantic. First place went to *Majestic*, followed by *Aquitania* and *Leviathan*. *Olympic* arrived at Harland and Wolff on 10 December 1923 for her scheduled winter overhaul and returned to Southampton on 9 February 1924.

March of that year was to see *Olympic* involved in yet another collision. On 22 March 1924 *Olympic* was backing out from Pier 59 into the Hudson River at the start of her return journey to Southampton. Coming down the Hudson towards her was the Bermuda Line vessel *Fort St George*. It would appear that *Fort St George* was too near the Manhattan shore to avoid a collision and struck the reversing *Olympic*. It is thought, also, that *Fort St George* may have been trying to compete with her rival *Arcadian* which, sensibly, was well over towards the Jersey shore. *Olympic*'s damage was slight and, after an initial inspection, she continued her voyage with scarred plates and a cracked stern post, repaired during her winter 1925/26 overhaul. *Fort St George*, however, was less fortunate and she suffered damage to her decks, railings and lifeboats, as well as a broken mainmast. The inquiry into the accident, in July 1927, found *Fort St George* to blame for travelling too near the Manhattan shore and at too fast a speed.

Olympic proceeds up the Hudson River to Pier 59, at the end of another transatlantic journey, with the Manhattan skyline in the background.

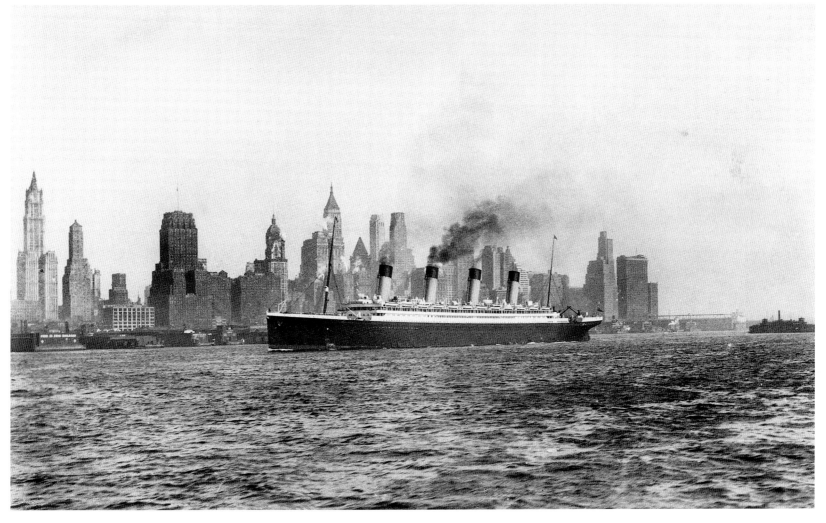

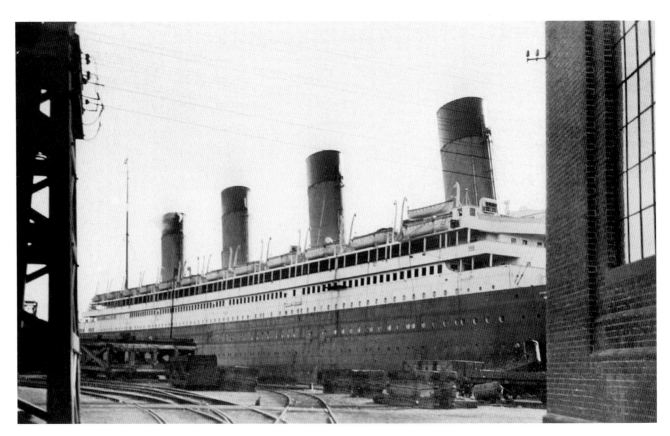

The words 'Olympic (dry dock) Aug. 7th 1922' are written on the reverse of this postcard. Possibly there to fit additional lifeboats?

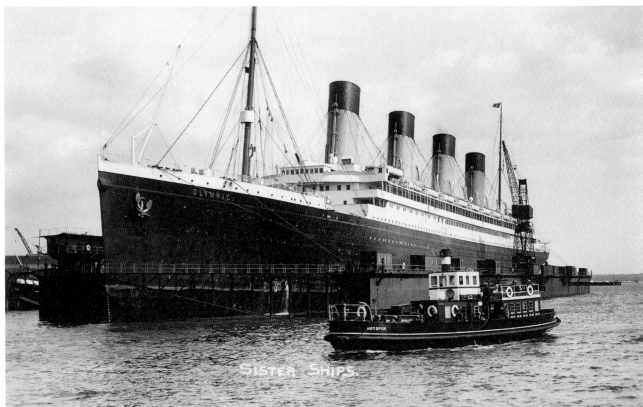

Olympic, in the floating dry dock at Southampton, towers above the tug *Hotspur* in the foreground.

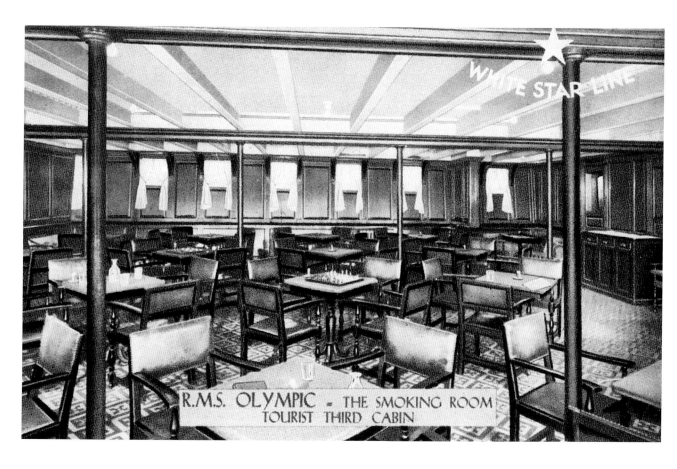

R.M.S. OLYMPIC - THE SMOKING ROOM
TOURIST THIRD CABIN

The chess set appears again, on this company-issued card, as the second-class smoking room becomes 'Tourist Third Cabin'.

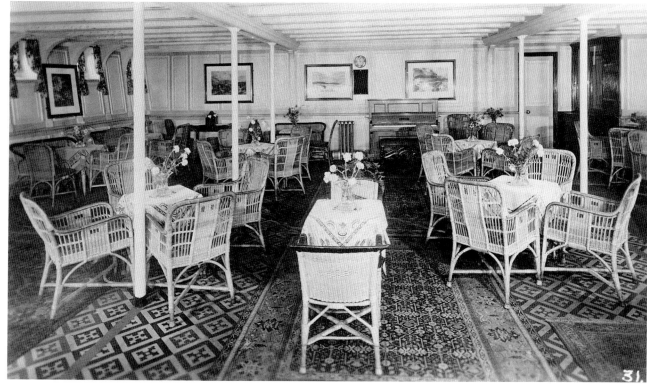

A corner of the tourist third cabin lounge with carpets over a lino floor and large vases of flowers on each table. Note the piano against the wall in the background. (Kingsway)

Lord Pirrie, Chairman of Harland and Wolff, had died of pneumonia on 7 June 1924 whilst returning from South America, and *Olympic* carried his body from New York to Queenstown from where it was taken to Belfast for the funeral. The Prince of Wales, later to become King Edward VIII, travelled on *Olympic* from New York to Southampton on 25 October 1924.

With the reduction of immigrant quotas to the USA, the need for a 'basic' third class was less important and the travelling public began to expect greater comfort

A broadside view of the giant *Olympic* once again in the floating dry dock at Southampton. Note the White Star pennant atop her mainmast.

from the transatlantic shipping companies. The North Atlantic Conference of April 1925 introduced 'Tourist Third Cabin' class. This new class of travel would combine the less expensive cabins in second class with the better cabins in third and the fare would be slightly higher than that for the existing third class. Three years later, second class was abolished completely and 'Tourist Third Cabin' became 'Tourist' class.

The IMM had not been as successful a combine as J. Pierpont Morgan had hoped and his son, J. Pierpont

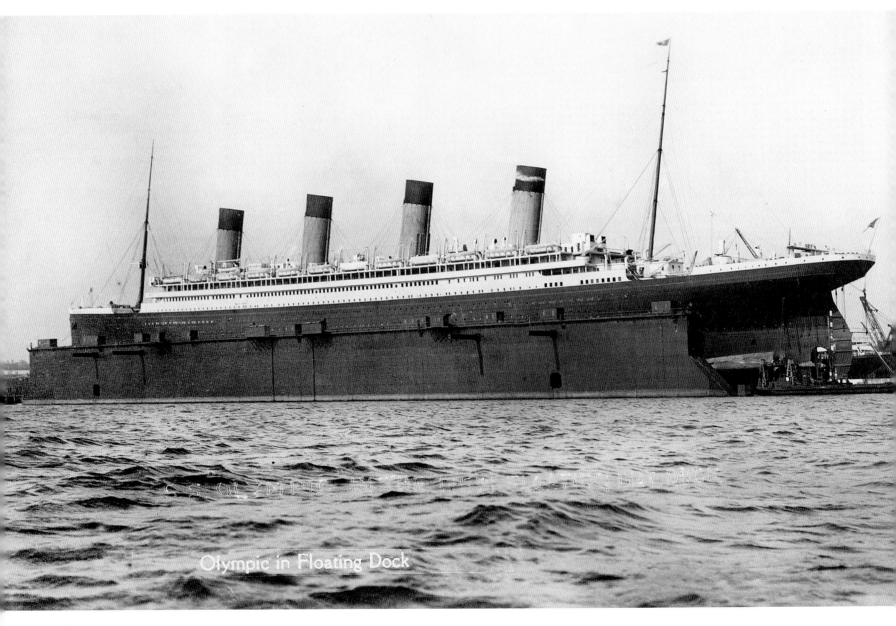

Olympic in Floating Dock

The 1920s decor in this first-class cabin is a far cry from the first-class suite illustrated in the colour section. (Kingsway)

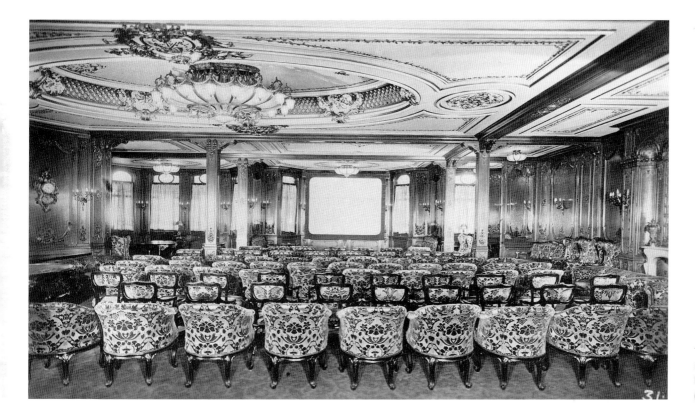

The portable cinema screen installed in *Olympic*'s first-class lounge during the 1927/28 refit. (Kingsway)

The temporary altar on board *Olympic* is illustrated on this company-issued card carrying, on the reverse, an advertisement for 'RMS Olympic. The Largest Triple-Screw Steamer in the World.'

Morgan Jr, was looking for a way out. This exit appeared in the form of Lord Kylsant (Sir Owen Phillips). Kylsant, Chairman of the Royal Mail Steam Packet Company, had acquired Harland and Wolff after the death of Lord Pirrie and went on to purchase White Star Line from the IMM for £7 million in November 1926. Many thought at the time that this price was excessive for the fleet of over twenty vessels.

Once again a British company, White Star Line Ltd was created in January 1927, becoming a subsidiary of the Royal Mail Group. Shortly after the acquisition, design work began on White Star Line's proposed new liner *Oceanic* to replace the slower *Homeric*. The order for this £3.5 million, 60,000-ton motor vessel had been placed with Harland and Wolff despite the worsening financial situation of Kylsant's empire. The Cherbourg tenders *Nomadic* and *Traffic* were sold to Compagnie Cherbourgeoise de Transbordement but continued to service White Star Line's vessels.

After her refit of winter 1925/26, *Olympic*'s transatlantic schedule was increased to sixteen round-trip voyages per year and for the next four years her passenger complement was averaging at between 800 and 900 per crossing. It is said that during the 1920s *Olympic* carried over 39 per cent of White Star Line's Southampton–New York–Southampton traffic.

The refit of December 1927 to January 1928 concentrated on a major upgrade of *Olympic*'s passenger accommodation, much more so than at any prior overhaul. This resulted in a considerable reduction in her passenger capacity and she emerged with accommodation for 675 in first, 561 in tourist and 819 in third class. A considerable number of these cabins were interchangeable between first and tourist or tourist and third classes. Many additional first-class cabins were given private facilities and more suites were allocated to 'B' deck. Unlike her sister *Titanic*, *Olympic*'s suites did not have private promenade areas.

Recognising the popularity of the new 'movies', a portable cinema screen was installed in both first and tourist classes. Additionally, both the first- and tourist-class dining rooms were fitted with a dance floor and the Café Parisien became the Parisian Garden Café. Previous third-class areas were given over to tourist class, including the smoking and general rooms, and the promenade

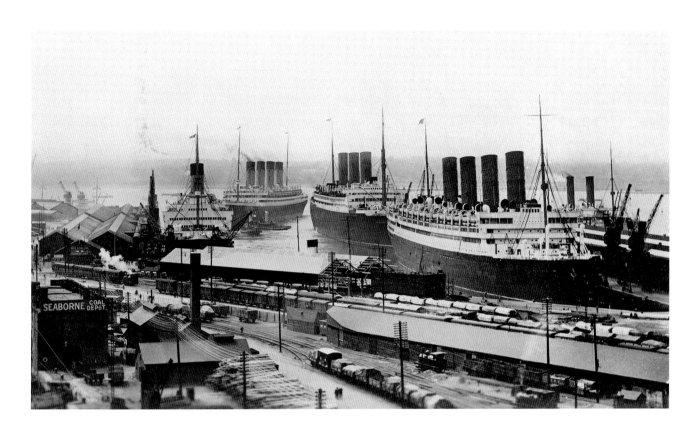

Four giants at the Ocean dock on a busy day in the 1920s. From left to right: *Homeric*, *Olympic*, *Berengaria* and *Aquitania*. (F.G.O. Stuart)

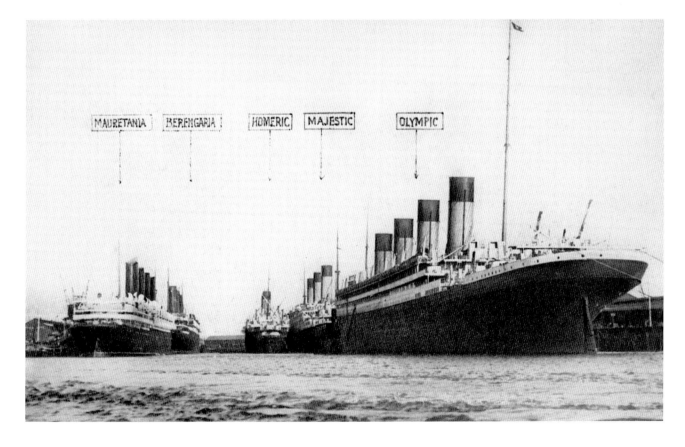

Only *Aquitania* is missing from this 1920s line-up. Apparently no White Star eastbound service is planned for the next seven days! (Photochrom)

areas on the stern. For third class a new smoking room and lounge were allocated to 'D' deck, as well as new promenade areas in the forward section. Both tourist and third classes each had their own purser's office and the third-class dining room seating was reduced by 147 to 326. Finally, crew accommodation was fitted with improved lighting and ventilation.

In 1928, after her refit, *Olympic* made sixteen round-trip voyages, still keeping to her average speed of 21 knots, whilst in 1929 her owners carried more first-class passengers than any of the competition. Despite the added boost of the US immigration quotas from the UK being increased from 34,000 to 65,000 annually, competition from more modern European liners and the growing Depression began to affect the business of both Cunard and White Star Line.

Olympic and *Homeric* are in the foreground in this aerial view of the Ocean dock. (Valentines Aerial)

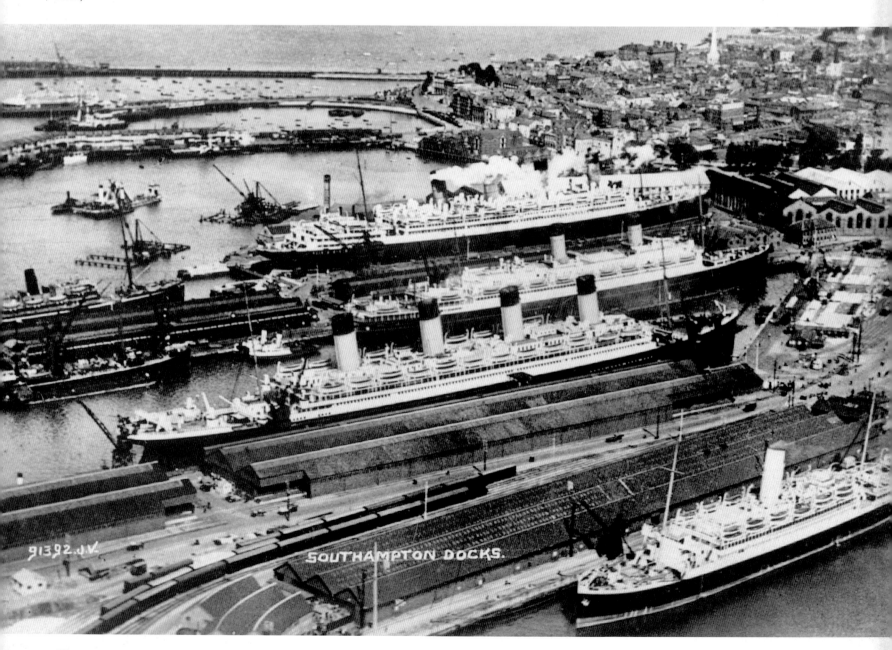

END GAME

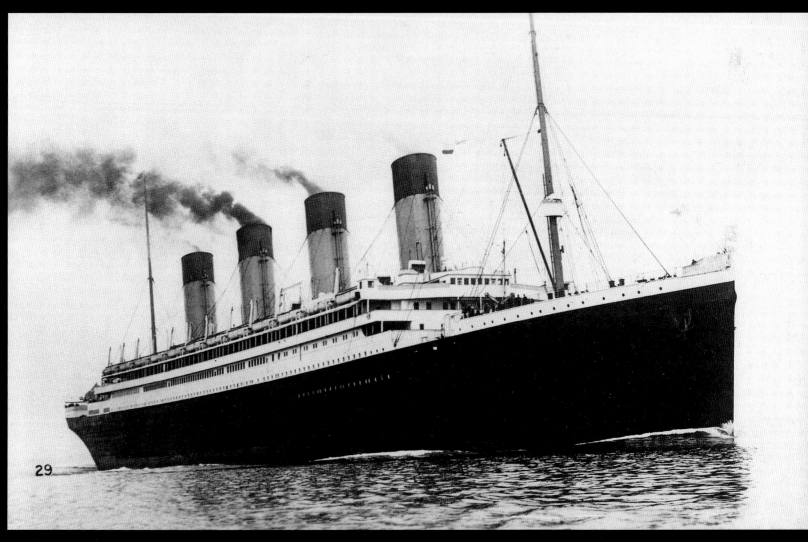

29

Towards the end of her career,
Olympic continues to impress.
(Real Photo Series)

North German Lloyd's *Bremen* and her sister ship *Europa* attracted the travelling public, who were seeking more modern vessels, away from the ageing British transatlantic fleet.

The worsening effects of the Depression prompted the decision, on 29 July 1929, to 'temporarily abandon' construction of the new *Oceanic* at Belfast. This was followed in October by the financial Wall Street Crash. Things were not looking good for the transatlantic travel trade.

As his Royal Mail Group faced ruin, Kylsant continued to borrow more and more money, which he juggled between his ailing companies. The Aberdeen & Commonwealth Line had been purchased in the name of White Star Line for nearly £2 million, the money having been borrowed from the Australian government who refused to extend the payment period. Ships were sold

Schnelldampfer „Bremen" des Nordd. Lloyd

for only £500,000, resulting in a loss to White Star Line of nearly £1.5 million. Additionally, Kylsant bought out Shaw Savill and Albion for nearly £1 million despite already holding a controlling interest.

Finally his manoeuvrings caught up with him and he was found guilty of providing false information with regard to the 1928 Royal Mail Group share prospectus. Sentenced to six months' imprisonment in 1931, his empire disintegrated in June 1932.

Olympic, meanwhile, continued her transatlantic voyages making sixteen return crossings in 1930 and still averaging 21–22 knots. That year, however, was to see the first financial loss in White Star Line's history. There had been quite a fall-off in passenger numbers as traffic switched to the newer European liners, especially Germany's *Bremen* and *Europa*. In order to compete, Britain's ageing vessels required constant modification. During her winter overhaul of 1925/26 it was discovered that small cracks were appearing near *Olympic*'s bridge and the stern frame which had been fitted after the *Fort St George* collision,

despite its recent installation, had begun to show signs of deterioration.

The annual survey of 1930 revealed further weakening of the bridge area and questions were being asked about the strength of the hull. Considerable welding temporarily solved the problems but the Board of Trade, although satisfied, placed *Olympic* on their 'Confidential Watch List'.

In 1931, *Olympic* made another sixteen return passages, continuing to maintain her previous average speed. Despite being the second most profitable vessel in the White Star fleet, *Olympic* was only averaging 450 passengers per crossing, a fall-off of nearly 25 per cent.

During this period, whilst on layover at New York, *Olympic* made a few four- and three-day cruises to Halifax and 'nowhere' respectively. A reunion of Canadian veterans from the Great War was held on board during one of the visits to Halifax.

Further weaknesses in the hull began to be detected and the Board of Trade granted *Olympic* a certificate of seaworthiness for only six months. This was later

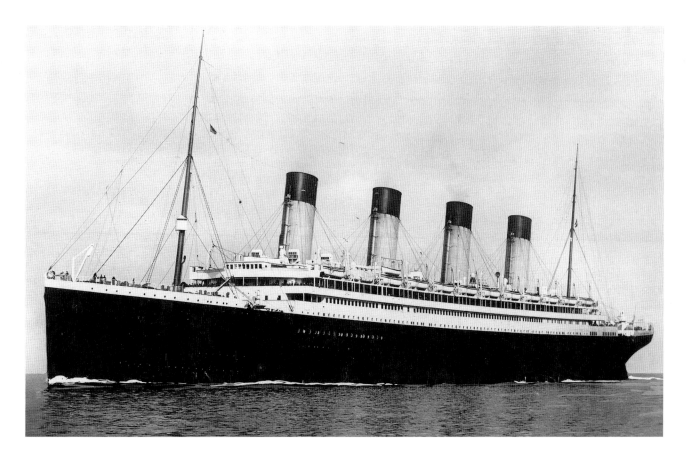

This 1930s postcard of *Olympic* was sold on board during her Whitsun UK 'cruise to nowhere' in May 1932.

extended for a further half year. The round-trip voyages of 1932 were reduced to eleven and her speed was restricted to 21 knots. It is said that this reduction in speed was to reduce fuel consumption but was probably as a result of Board of Trade restrictions. The average number of passengers carried had now fallen to 429 per voyage and, in fact, on her first journey out she had on board only 249, which rose to 332 for the return. It was in 1932 also that she carried only 202 passengers on one particular voyage, her lowest ever complement to date.

After the experiment at New York, Olympic made two 'three-day cruises to nowhere' from Southampton in May and August 1932 but, towards the end of that year, White Star Line finally acknowledged that she was showing

'signs of age'. Reflecting the reduction in passenger traffic, Homeric was removed from Atlantic service and placed permanently on cruising duties.

Both 1932 and 1933 were to be years during which White Star Line made financial losses. At the end of the last voyage of 1932, cracks were found below Olympic's two main engines and, on her first voyage from New York to Southampton in 1933, she carried only 125 passengers, believed to be her lowest ever payload. Increased mail revenue only partially offset the effects of the decline in passenger numbers, however. Olympic's registered passenger capacity was, in July 1933, reduced to 618 first, 447 tourist and 382 third class. This reduction resulted in the removal of four of her 28ft aft lifeboats on each side.

Nantucket lightship LV112 was built to replace lightship 117, sunk in a collision with Olympic on 15 May 1934. (LEIB Image Archives)

By 1933 passenger numbers were down to 350 per crossing but, despite these low figures, *Olympic*'s average speed had gone back up to 22 knots and she beat her 1911 fastest crossing on three occasions. However, both Cunard and White Star Line were facing serious financial difficulties. That year was also to be White Star Line's fourth consecutive loss-making year and their older vessels were being sold for scrap or to other companies. In the face of serious competition from European shipping lines, this situation could not continue and the British government was approached for assistance.

Parliament offered to guarantee a loan of £9.5 million, but only on condition that the two companies agreed to merge. The board members of Cunard and White Star Line met on 30 December 1933 to discuss terms and the North Atlantic Shipping Bill was passed on 28 March the following year. Cunard-White Star Line Ltd was registered as a company on 10 May 1934 with 62 per cent of the shares being held by Cunard and 38 per cent by Ocean Steam Navigation Co. (White Star Line).

Olympic and *Mauretania* would be the first two express vessels withdrawn from service after the Cunard-White Star merger of 1934.

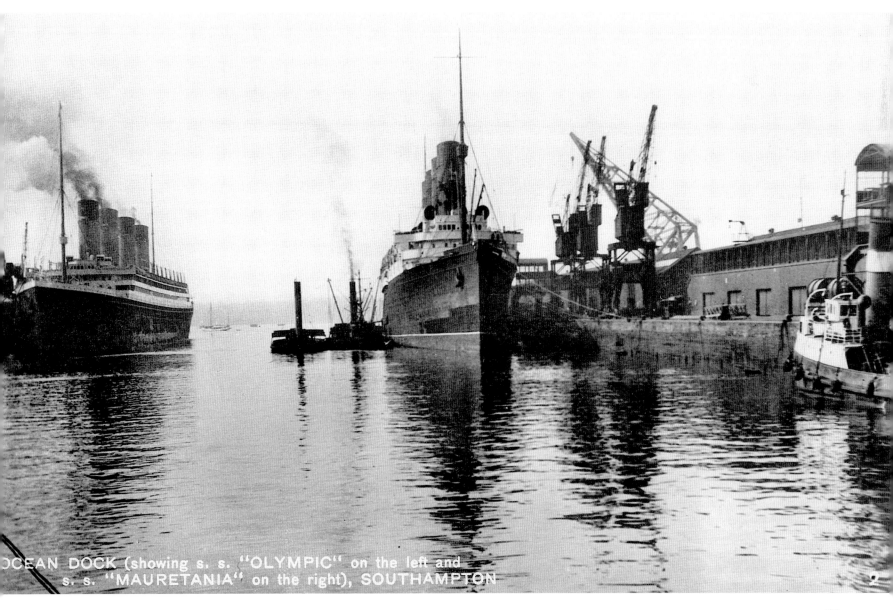

OCEAN DOCK (showing s. s. "OLYMPIC" on the left and s. s. "MAURETANIA" on the right), SOUTHAMPTON

Almost immediately three of White Star Line's vessels, *Adriatic*, *Albertic* and *Calgaric*, were sent for scrap and *Olympic*'s future began to look bleak.

Off the north-east coast of the United States, Nantucket Island's lightship station had a reputation for its number of near collisions with passing vessels. The current lightship on that station was LS117, introduced in May 1931. Being 135ft long and fitted with an incandescent light, she also broadcast a radio beacon and was powered by oil-burning steam engines.

In 1933 she had suffered a near miss from the US liner *Washington*. It was not uncommon for large liners to approach the lightship too fast and too close, and only a month before, the wireless operator of the Nantucket lightship had said: 'One of these big liners will just ride through us one of these days.'

Now in the ownership of the newly formed Cunard-White Star Line, *Olympic* was approaching the Nantucket lightship at the end of her westbound crossing on 15 May 1934. With Captain John Binks in command, and carrying only 200 passengers, *Olympic* had reduced her speed to 10 knots, at five o'clock that morning, due to fog. During the night of 14 May Captain Braithwaite, on board LS117, had commanded that all his ten-man crew be awake with lifejackets on and that the ship's lifeboat be made ready as several vessels had approached perilously close to the vulnerable vessel in the fog.

LS117's radio beacon was in operation, broadcasting Morse code four dashes which indicated the presence of a specific lightship. It seemed that *Olympic* had been steering to the radio beacon, a practice frowned upon but often followed. This would explain the many near misses experienced by a considerable number of light-

An artist's impression of Cunard-White Star Line's new *Queen Mary*. Her launch, on 26 September 1934, signalled the beginning of the end for *Olympic*. (Valentines Aerial)

ships. Passing vessels would swerve away at the last minute leaving the little lightship bobbing violently in their wake.

At 10.55 a.m. the lightship's siren was audible but fog distorted the direction of the sound. *Olympic* attempted to contact the lightship by radio but to no avail. At 11.06 a.m. *Olympic*'s lookouts saw the red lightship dead ahead and signalled the bridge. By this time the giant liner's speed had been reduced to 3 knots and, upon receiving the lookout's warning, the engines were put into reverse. All this was too late, however, and the 46,439-ton *Olympic* smashed into the little lightship, which heeled over and sank. There had been no time to lower the lifeboat and the injured crew clung desperately to the wreckage. *Olympic*'s two emergency boats were lowered to search for survivors and, of the crew of eleven, seven were picked up, including her 65-year-old captain, but sadly three were to die later. After almost three hours *Olympic* resumed her course towards New York having abandoned the search for the remaining four men which was made too difficult due to the thick fog.

At the ensuing inquiry *Olympic*'s Captain Binks stated that the ship's course had indeed been set by the lightship's radio beacon but had been set to ensure the lightship was three points off the starboard bow. Only thirteen days before this incident the US Lighthouse Authority had issued a notice to mariners warning ships to steer clear of the lightship.

White Star Line admitted full liability and, in January 1936, a settlement was agreed after the lightship's value was reduced from $500,000 to $325,000. Upon her arrival in New York, *Olympic*'s hull was inspected but, other than scratched paint and a dent in her bow, little significant damage was discovered.

A temporary lightship, LS106, was rushed on to station until the permanent replacement, LS112, was launched at Wilmington, Delaware, in 1936. At 915-ton displacement and 149ft long, LS112 was the largest lightship yet built in the USA and, with her forty-three watertight compartments, she was considered to be 'the unsinkable lightship'. She was fitted with a short-range pulse that

Olympic's last three funnels in a photograph taken on 9 January 1935, just weeks before her last commercial voyage.

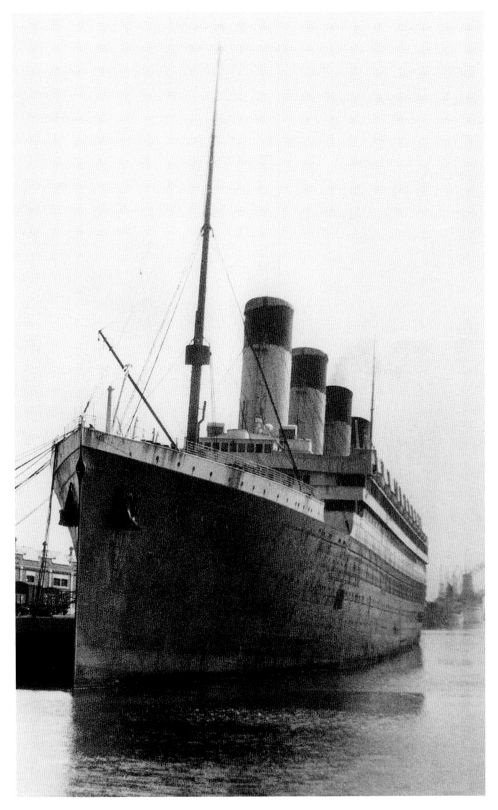

Empty and forlorn, *Olympic* was laid up pending disposal at the end of her last transatlantic voyage on 12 April 1935.

transmitted a musical note warning vessels that they were within a 15-mile range of the lightship. LS112 was retired in 1975 and is currently preserved at the Intrepid Sea-Air-Space Museum in New York at their Hudson River location where she is open to the public.

Olympic's next arrival in New York, on 5 June 1934, was the last occasion upon which she would arrive at White Star Line's Pier 59. The joint company's vessels would now use Cunard's Pier 54. During 1934 *Olympic* made fifteen return crossings, half for White Star Line and the remainder for the joint company. She would be the first of the White Star Line vessels to fly both flags from her mainmast: White Star Line's red pennant with a white star above Cunard's golden lion. The position of the flags was reversed on Cunard vessels.

The giant *Queen Mary* was launched at John Brown's Yard on the Clyde on 26 September 1934 and *Olympic*'s future began to look even more insecure. The à la carte restaurants on both *Olympic* and *Majestic* were closed for economic reasons in October 1934. A month later the Board of Trade surveyor certified *Olympic* after her annual refit stating that no repairs were necessary.

In January 1935, however, it was announced that *Olympic* would be withdrawn from the Atlantic service at the end of the spring schedule, despite an increase in passenger traffic as the effects of the Depression lessened. Commanded by Captain Reginald Peel, *Olympic* departed Southampton for her last transatlantic voyage on 27 March 1935, arriving back on 12 April. Amongst her crew was Frederick Fleet who, as lookout on *Titanic*, had first sighted the iceberg.

In her lifetime *Olympic* had made 257 return crossings. The day after her arrival back in Southampton, Cunard-White Star Line announced the cancellation of *Olympic*'s proposed summer cruise schedule pending a decision about her future. She was placed in lay-up at berth 108, joining Cunard's *Mauretania* which was set to depart for the scrapyard on 1 July.

With her officers and crew having joined other vessels, the deserted *Olympic* lay at her berth. The 'A'-deck promenade was enclosed by canvas and her white superstructure had become streaked with rust.

On 20 August potential purchasers were invited to inspect the forlorn vessel. Sir John Jarvis, the high sheriff

of the, relatively, wealthy Surrey, had persuaded his county to 'adopt' the underprivileged town of Jarrow located on the north-east coast of England. Sir John purchased *Olympic* for almost £100,000 on 10 September 1935 and promptly sold her to Jarrow shipbreakers Thos. Ward & Co. Ltd of Sheffield on condition that the demolition would take place at Palmers Yard, Jarrow. Jarrow had been particularly badly hit by the Depression and there was considerable unemployment in the area. Work on *Olympic*'s demolition would provide work over the next eighteen months for almost 5,000 men. Under the command of Captain P. Vaughan, *Olympic* departed Southampton for the last time on 11 October 1935 at 4.12 p.m. Proceeding down Southampton Water she passed her two ex-running mates, *Homeric* and *Majestic*, at the Ocean dock. Despite her whistle of acknowledgement and goodbye, there was no reply.

Enormous crowds of people awaited her arrival at the Tyne at 10 a.m. two days later, far more than had been at Southampton to see her off, and she reached Palmers Yard at 3.50 p.m., having awaited the high tide for nearly six hours. Preceded by the harbour master's launch, six tugboats were on hand to assist with *Olympic*'s arrival. *Hendon* and *Joffre* took her bow, *Wearmouth* was allocated the starboard side, and *Plover* and *George V* took the stern. *Great Emperor* stood ready to assist if required. The huge crowds had watched in silence, but as *Olympic* sounded three long blasts on her whistles, they broke into loud cheers. Within the hour she was tied up and her engines were stilled for the last time. The 100 men of the delivery crew were paid off and the silent vessel awaited her demolition.

Olympic was open to viewing by the public, for a fee of 1s to charity, for ten days until 26 October. Many thousands took this last opportunity to visit the famous vessel, following chalked arrows leading them to dimly lit staterooms. The few brighter lights illuminated some of the larger public rooms. During this period the auctioneers began listing the items to be sold. Several smaller items 'disappeared' during the public's viewing period!

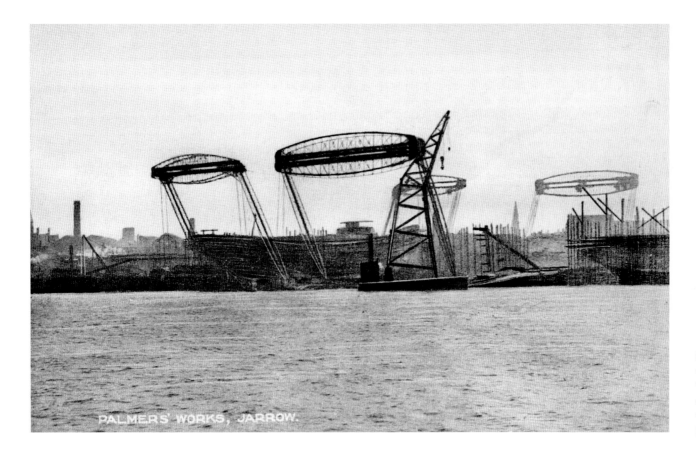

PALMERS' WORKS, JARROW.

Palmers Yard at Jarrow. *Olympic* was sold to shipbreakers Thos. Ward & Co. Ltd for £100,000 on condition that the demolition would take place here. (Hey of Newcastle)

Messrs Knight, Frank and Rutley handled the auction of her fixtures and fittings, numbering over 4,500 items in a 365-page catalogue that sold for 2s 6d. The auction began on 5 November and was to last for ten days.

The auctioneer, Mr Arthur Wright, began the proceedings with the words: 'I feel I owe the Olympic my apologies before starting my undignified labours.' The first lot to be sold was a pair of settees, from the engineers' smoking room, which went for £7, and the largest purchaser, of 394 lots, was the Majestic Lido Hotel in Douglas, Isle of Man. The three first-class lifts were sold for £30 each. Interestingly, the carpet from Olympic's à la carte restaurant was lifted and placed in Aquitania's Grill Room. The White Swan Hotel at Alnwick, Northumberland, purchased the first-class lounge and many of Olympic's fittings went to Sheffield's Cutlers Hall. Panelling from the à la carte restaurant has been installed in Celebrity's cruise ship Millenium.

Demolition work commenced after Christmas 1935 and on 19 September 1937 the cut-down hull was towed to Inverkeithing for final dismantling. The work was finished and the ship's registration was removed on 4 February 1939.

Late in the afternoon of 11 October 1935, Olympic begins her journey from Southampton to the Tyne. (J. Hooley)

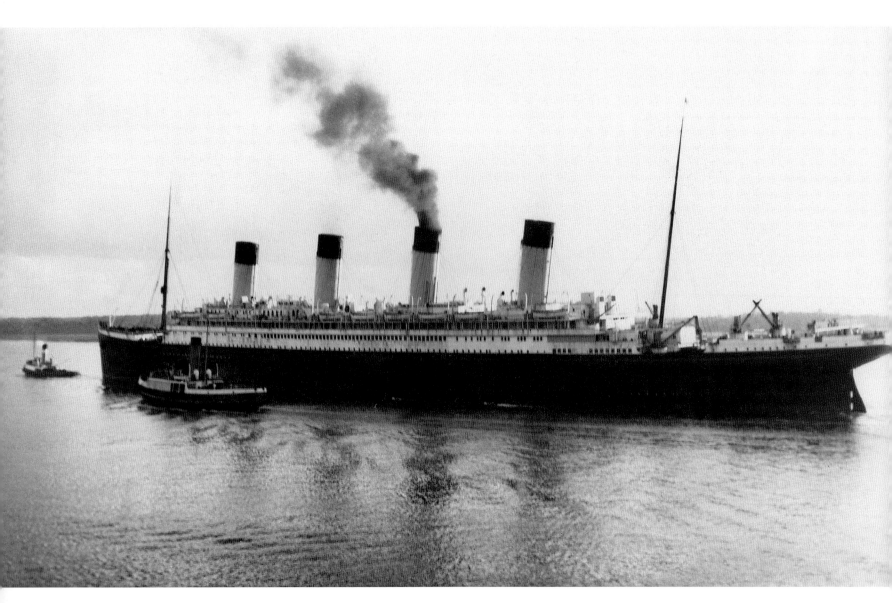

Less than a month after the departure from Jarrow, on 17 October 1937, J. Bruce Ismay died following a stroke in London.

The United Kingdom entered the Second World War on 3 September 1939 and, with hindsight, despite Cunard-White Star's claims that the Depression had drastically reduced passenger traffic and she was no longer economical to operate, *Olympic* would have proved invaluable as a troopship during the ensuing conflict. She certainly had several more contributory years remaining at the end.

Receiving no acknowledgement from *Homeric* or *Majestic* at the nearby Ocean dock, *Olympic* bids farewell to Southampton. (J. Hooley)

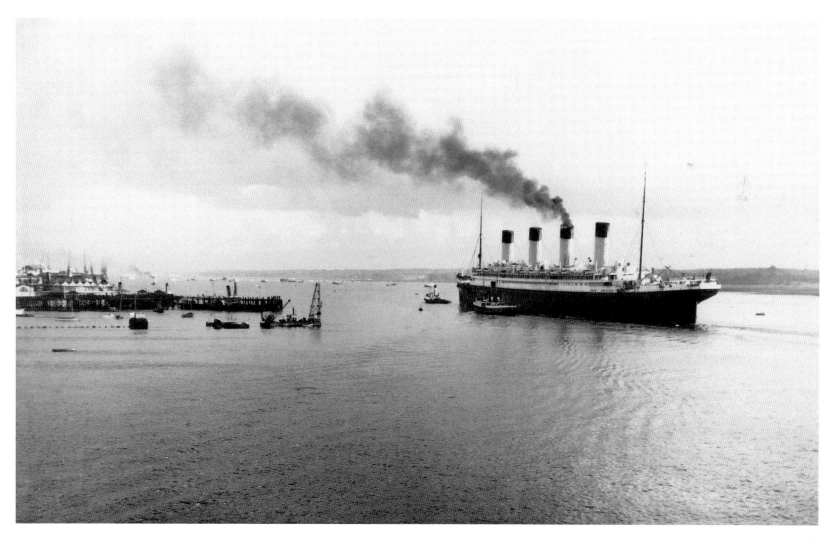

END NOTE

The last illustration in my book is *Olympic*'s farewell to Southampton as she set off on her final voyage on 11 October 1935. I have told you of her fate upon arriving at the demolition yard, but wanted to leave you with a lasting view of this beautiful vessel afloat and under her own power. She deserves no less.

BIBLIOGRAPHY

Bell, D., *The Death of the Olympic* (Master Mariner)

Chirnside, Mark, *RMS Olympic: Titanic's Sister* (The History Press)

Haws, Duncan, *Merchant Fleets* (White Star Line)

de Kerbrech, Richard, *Ships of the White Star Line* (Ian Allan Publishing)

Louden-Brown, Paul, *The White Star Line 1869–1934: An Illustrated History* (The Titanic Historical Society)

MacAlindin, Bob, *No Port in a Storm* (Whittles Publishing)

Mills, Simon, *RMS Olympic: The Old Reliable* (Waterfront Publications)

Sisson, Wade, *Racing Through the Night: Olympic's Attempt to Reach Titanic* (Amberley Publishing)

THE TITANIC COLLECTION

For the full *Titanic* experience visit The History Press website and follow the *Titanic* link

www.thehistorypress.co.uk

The History Press

The destination for history
www.thehistorypress.co.uk